Masterpiece in Residence

Juan Sánchez Cotán's
*Still Life with Quince, Cabbage,
Melon, and Cucumber*
from the San Diego Museum of Art

Juan Sánchez Cotán's Still Life with Quince, Cabbage, Melon, and Cucumber has been organized by the Meadows Museum and is funded by a generous gift from The Meadows Foundation.

First published in 2024 by Scala Arts Publishers, Inc.
c/o CohnReznick LLP
1301 Avenue of the Americas, 10th floor
New York, NY 10019
www.scalapublishers.com

In association with the Meadows Museum, SMU
5900 Bishop Boulevard
Dallas, TX 75205
www.meadowsmuseumdallas.org

978-1-78551-418-0
Library of Congress Cataloguing-in-Publication Data: a catalog record for this book is available from the publisher. Author: Cherry, Peter. | Dotseth Amanda W. | Title: *Meadows Museum Masterpiece in Residence Juan Sánchez Cotán's Still Life with Quince, Cabbage, Melon, and Cucumber from the San Diego Museum of Art* | Description: Dallas and New York: Meadows Museum, SMU in association with Scala Arts Publishers, Inc., 2024. Identifiers: LCCN 2023951233 | ISBN 978-1-78551-418-0

Masterpiece in Residence

Juan Sánchez Cotán

PETER CHERRY

Director's Preface

The idea to launch a loan series dedicated to exceptional works of Spanish art from American collections was one that inspired hours of discussion between myself and the late director of the Meadows Museum, Mark Roglán. Which works would we feature in such a series, assuming we could have our choice? Some of the artists who leapt to mind are well known to those familiar with the art historical canon, such as El Greco, Velázquez, Picasso, and Dalí. But we also wanted to take this opportunity to showcase the brilliance of artists who are not as well known to the public, like the still-life painter Juan Sánchez Cotán. It was, in fact, the opportunity to collaborate with the San Diego Museum of Art and to borrow *Still Life with Quince, Cabbage, Melon, and Cucumber* that inspired this series in the form it would ultimately take. I am so pleased, therefore, to inaugurate this program with Sánchez Cotán's captivating canvas.

Masterpiece in Residence is intended to invite more intimate contemplation on individual works of art and to foster dialogues with works in the Meadows Museum's permanent collection. The program underscores the importance of American holdings within the history of Spanish art and beyond the canon typically bracketed by "El Greco to Goya," by introducing North Texas audiences to artists and media not represented in the Meadows collection. It is hoped that this format will yield new insights on a diverse range of artworks, both celebrated and understudied. The legacy of the program is a series of monographs, published in collaboration with Scala Arts Publishers, wherein a scholar is invited to meditate on the story of a featured masterpiece and to reflect on previous studies of that work. The essay written by Peter Cherry for the present volume offers revelatory insights on Sánchez Cotán's painting, setting a high bar for future volumes.

Still Life with Quince, Cabbage, Melon, and Cucumber has long captivated the imaginations of all who encounter it. Its accomplished verisimilitude, naturalism, play of light and shadow, and balanced composition leave little doubt as to the extraordinary talent of Sánchez Cotán, who is often considered the father of the Spanish still-life tradition. Whatever this canvas meant to its maker or to its seventeenth-century viewers, it remains an absolute pleasure to behold, particularly on account of its striking simplicity. Today's audiences are especially moved by the painting, their taste having been honed by the clean lines and compositions characteristic of modernism and the color fields of mid-twentieth-century Abstract Expressionists. We are perhaps more inclined than our ancestors to appreciate artistic restraint. Still, with its incipit modernism, there is nothing quite like this composition in the history of art.

The painting's protagonists—comestible fruit and vegetables—dangle from exquisitely painted strings or rest within a space that is not easy to define: is it the window ledge of a larder? What lies in the black void beyond? Indeed, it is the negative space of this painting that has inspired the most fanciful conjectures, as Cherry's historiographical analysis shows. Scholars have long conjured mystical and modernist meanings from a painting that is ultimately a relic of Baroque Spain. As Cherry notes, such readings—ranging from the speculative to the outright anachronistic—prove tenacious, whether or not they can be defended. In the end, we still do not know quite what to make of this unusual still life, created by an artist who, it seems, suddenly abandoned a lucrative career to take orders as a lay Carthusian. In what follows, however, Cherry offers some promising new inroads.

I would like to express my gratitude to our colleagues at the San Diego Museum of Art who so generously facilitated the loan of Sánchez Cotán's still life, which is a favorite among their visitors and therefore rarely travels. Thanks go especially to Roxana Velásquez, the Maruja Baldwin Executive Director and CEO, and Michael Brown, Curator of European Art. I am grateful to Peter Cherry, Lecturer in the history of art at Trinity College in Dublin, for his rich scholarship on the painting; to Anne Keefe and Danielle Naylor for their editorial work on this volume; to Miranda Saylor for supervising the final stages of this publication; to the entire Meadows team responsible for the exhibition and programming surrounding the loan (their names are included at the end of this volume); and to the entire production team at Scala.

Finally, it is the steadfast support of Southern Methodist University, the Meadows Museum Advisory Council, and especially The Meadows Foundation that makes such meaningful, focused projects like this one possible. We are infinitely grateful to all.

Amanda W. Dotseth
Linda P. and William A. Custard Director
Meadows Museum, SMU

SÁNCHEZ COTÁN AND THE STILL LIFE

In memoriam Bill Jordan

People standing in front of *Still Life with Quince, Cabbage, Melon, and Cucumber* in Toledo in 1600, like those in the gallery today, would have been surprised and mesmerized by it. It is unlikely that they would have been prepared for pictures in which such familiar foodstuffs were so dramatically transformed. The fruits and vegetables have been slowly and painstakingly painted to look very like the real thing. But why are they presented in this window frame giving onto a dark void? And why are the quince and cabbage hanging on strings? The answer to these questions lies in the signature of the author on the front face of that window frame: "Juan Sánchez Cotán made this." The signature tells us that we are looking at a representation, something we now call a still-life painting, created by a named individual. Seeing the still life as an artistic performance demands that we admire the quality of the artist's achievement in representing reality, evidently

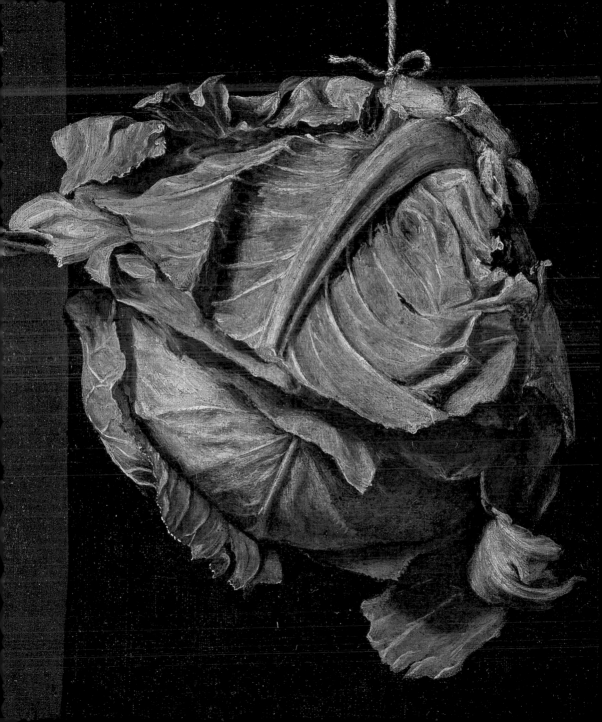

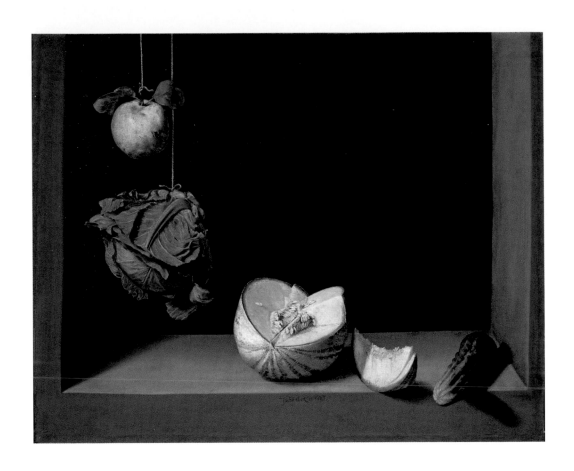

the result of his concentrated observation of the things before him. We are also driven to appreciate the calculated ingenuity of the illusionistic pictorial composition, with the melon and cucumber seemingly within the fictive space of the window frame and the quince and cabbage apparently hanging in front of it.

Sánchez Cotán's still life proclaims an awareness of classical values of mimesis in art. The story of the Greek painter Zeuxis's painting of a basket of grapes was a part of the common lore of art by Sánchez Cotán's time. It was said that Zeuxis's grapes were so well painted that birds flew down and pecked at them.[1] It is not surprising in this respect that Sánchez Cotán painted a still life with grapes.[2] In an associated story, Zeuxis himself lost out to Parrhasius in a painting competition; Zeuxis tried to push back a curtain draped over a painting only to discover that it *was* the painting.[3] The tales encapsulate a number of ideas, not least of which was the belief that the goal of painting is to achieve a representation so realistic it deceives the viewer into thinking it is the actual thing.[4] This kind of deception is the driving force behind *Still Life with Quince, Cabbage, Melon, and Cucumber* (fig. 1). Obviously, this refers to the high-fidelity visual description of the foodstuffs, whose limited number intensifies the focus on the artist's representational virtuosity, and to the illusionism of the painting's format. The gray, painted window frame into which the fruits and vegetables are set is Sánchez Cotán's signature form of presentation and can be read, in essence, as his response to Parrhasius's curtain. It is the key element

Fig. 1. Juan Sánchez Cotán (Spanish, 1560–1627), *Still Life with Quince, Cabbage, Melon, and Cucumber*, c. 1602. Oil on canvas, 27 1/8 × 33 1/4 in. (68.9 × 84.5 cm). San Diego Museum of Art. Gift of Anne R. and Amy Putnam, 1945.43.

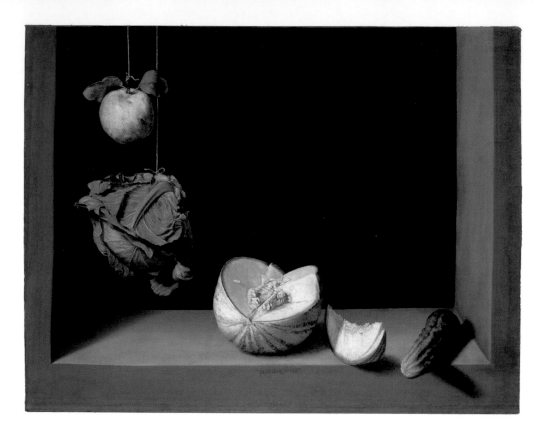

in the artist's purposeful staging of pleasurable deception. The window is painted to the same size as the canvas itself and the elementary single-point perspective—with the vanishing point placed at the center of the upper edge of the picture—articulates effectively the fictive space and eliminates the surface of the canvas.[5] The present condition of the painting shows a significant loss to the width of the right-hand side of the window frame; a very approximate reconstruction of the original dimensions of the painting goes some way in conveying the intended effect (fig. 2).[6]

Fig. 2. Digital reconstruction showing Sánchez Cotán's *Still Life with Quince, Cabbage, Melon, and Cucumber* (San Diego Museum of Art) with the edges of the window frame reinstated. Image by Peter Cherry and Jaime García Máiquez.

X-radiographs confirm the observation that Sánchez Cotán painted the window first, freehand, before adding the particularized still-life elements, which are painted individually in their allocated positions at different moments in the painting process.[7] Individual fruits and vegetables are drawn with rigorous lucidity. Sánchez Cotán observed shadows, and here the doubly cast shadow of the cucumber is projected plausibly on three planes of the window frame. Despite the fact that the elements do not touch or overlap, they nevertheless interact. The artist has recorded the shadow cast by the quince on the string of the cabbage and that of the melon on the slice, made luminous by its pinkish-white flesh. The capricious pictorial expedient of showing things suspended on cords expands the compositional and illusionistic potential of the picture.[8] Francisco Pacheco noted that artists could demonstrate their *ingenio* in composing still-life pictures, and the intuitive, artful arrangement of things in this picture would appear to do just that.[9] The quince and cabbage are played against the void in the upper part of the picture. Each element occupies a different, fictive plane; the melon appears to occupy the depth of the window frame, the melon slice and cucumber seem to project beyond its front plane into a space continuous with that of the spectator, and—given that the upper edge of the window is not shown—the quince and cabbage appear to hang at a point in front of it. Their location at or near the notional picture plane means that they are depicted "life-sized" or in their objective dimensions, thus increasing the impression of reality.

Still Life with Quince, Cabbage, Melon, and Cucumber
is first documented in the inventory of Sánchez Cotán's
possessions drawn up in Toledo in 1603 upon his retire-
ment from professional life in order to join the Carthusian
order as a lay brother (*lego*).[10] Seven other still lifes are
listed therein via cursorily described subject matter and
the majority of these can be identified with works known
today, although not all of them are by the artist's own
hand.[11] Paintings of religious subjects significantly out-
numbered still-life paintings in the inventory. The San
Diego still life is recorded here ("un lienzo adonde esta un
menbrillo [*sic*] melon pepino y un Repollo").[12] Another
painting represented a cardoon and a francolin, identifiable
with a painting in a private collection today.[13] There was a
still life with a tazza of chestnuts, garlic, and onions, whose
description corresponds with a painting known only in a
photograph.[14] A still life with baskets of cherries and apri-
cots was evidently a picture of which a number of copies
exist.[15] Three still lifes were said to be owned by two peo-
ple: Juan de Salazar owned *Still Life with Game Fowl* (fig.
3), painted the year before ("otro lienzo del cardo adonde
estan las perdizes que es el original de los demas—que es
de Ju° de Salazar"), of which the artist had made a copy
("otro lienzo de frutas q[ue] es como el de Ju° de Salazar").
Diego de Valdivieso owned a still life representing a basket
of grapes ("otro lienzo de frutas adonde esta un canastico
con ubas y es de Diego de Baldibieso") and *Still Life with
Game, Vegetables, and Fruit* (fig. 4) ("un lienzo de frutas
adonde esta el anade y otros tres pajaros q[ue] es de Diego
de Baldibieso").[16] Three other still lifes by Sánchez Cotán,

Fig. 3. Juan Sánchez Cotán
(Spanish, 1560–1627),
Still Life with Game Fowl,
1600–1603. Oil on canvas,
26 5/8 × 35 in. (67.8 × 88.7
cm). The Art Institute of
Chicago. Gift of Mr. and Mrs.
Leigh B. Block, 1955.1203.

Fig. 4. Juan Sánchez Cotán
(Spanish, 1560–1627), *Still
Life with Game, Vegetables,
and Fruit*, 1602. Oil on
canvas, 26 3/4 × 34 3/4 in. (68
× 88.2 cm). Museo Nacional
del Prado, Madrid, P-7612.

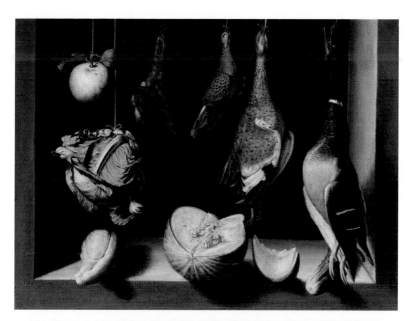

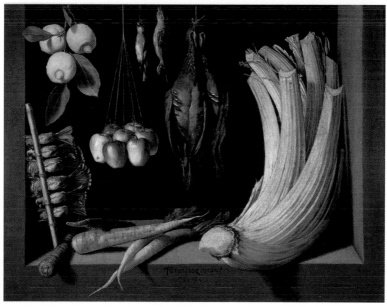

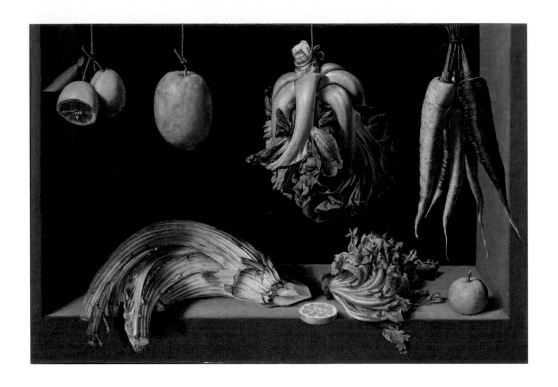

not mentioned in the inventory, are known today. *Still Life with Fruits and Vegetables* would appear to date from this time (fig. 5).[17] *Still Life with a Basket of Cherries, Roses, Lilies, Asparagus, and Peas* (fig. 6) is distinctive for its low viewpoint.[18] *Still Life with Cardoon and Carrots (Thistle Still Life)* (fig. 7) was found at the Granada Charterhouse and is likely to date from the time after Sánchez Cotán left Toledo; he did not develop a career as a still-life painter in Granada and probably painted the picture for himself.[19]

Fig. 5. Juan Sánchez Cotán (Spanish, 1560–1627), *Still Life with Fruits and Vegetables*, c. 1602. Oil on canvas, 26 3/8 × 38 3/8 in. (67 × 97.4 cm). Juan Abelló Collection.

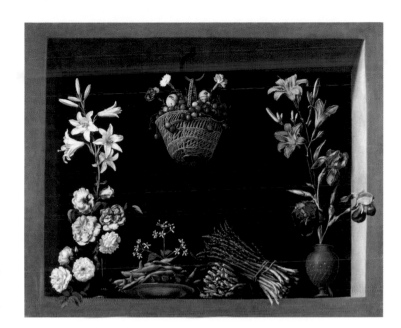

Fig. 6. Juan Sánchez
Cotán (Spanish, 1560–
1627), *Still Life with
a Basket of Cherries,
Roses, Lilies, Asparagus,
and Peas*, c. 1600–1603.
Oil on canvas, 35 3/8 ×
42 7/8 in. (89.8 × 109 cm).
Private Collection.

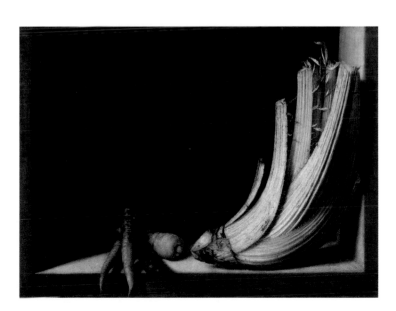

Fig. 7. Juan Sánchez
Cotán (Spanish, 1560–
1627), *Still Life with
Cardoon and Carrots
(Thistle Still Life)*,
between 1603 and 1626.
Oil on canvas, 24 3/8 ×
32 1/4 in. (62 × 82 cm).
Museo de Bellas Artes,
Granada.

Doubtless Sánchez Cotán was conscious of the special nature of his still lifes in his artistic production. He may have seen them as "experimental" pictures because they are so unlike his non-naturalistic figure paintings.[20] As for his clientele for these pictures, two are mentioned owning these works in his inventory, as already noted. Juan de Salazar was an important manuscript illuminator. Diego de Valdivieso is described in the artist's testament as a *cordonero*—literally a maker of cord, but actually an artisan responsible for the production of all manner of textile trimmings. He must have been an important client for the artist, as he is said to have owed him a substantial amount of money for (unspecified) paintings.[21] Salazar and Valdivieso were evidently trusted friends of the artist, given that he made them the executors of his estate and Salazar was given power of attorney to draw up his inventory. The means by which these clients—and others—acquired Sánchez Cotán's still lifes remains unclear. He may have painted his still lifes on speculation, rather than in response to a specific order, and if so, clients could purchase finished pictures directly from the studio. This practice would explain those still in the artist's possession in his inventory. On the other hand, as the inventory shows, the artist copied at least one of his works, probably for a particular client. Whatever the actual reasons for the presence of the still lifes in this document, it would imply a degree of the artist's attachment to and control over them: he kept them with him and enjoyed continued access to those owned by others.

It is generally assumed by viewers of Sánchez Cotán's paintings that his description of fruits, vegetables, and birds is the result of firsthand observation. But the question of the relationship of the paintings with experienced reality is not so straightforward. It is highly unlikely that the still lifes copied verbatim such arrangements of motifs in front of the artist. *Still Life with Game Fowl* (see fig. 3) was evidently used as a model for autograph copies; the picture was listed in the inventory as "another canvas of the cardoon where there are partridges, which is the original of the others," and, as has been noted, a copy of the work also appears in the document.[22] The fowl represented in *Still Life with Game, Vegetables, and Fruit* (see fig. 4) may have been painted individually from examples hanging before the artist. On the other hand, they may be a mix of observed objects and objects copied from other representations. His inventory lists a painting of a duck on panel ("un anade en tabla") and two painted studies representing respectively a sandgrouse and a brace of ducks ("dos cartones uno con una ganga y otro con dos anades"). It is not known if these were paintings from life, but they would have been very useful as models for such elements in other pictures. The use of the definite article in referring to *the* duck in the description of the Chicago painting in Sánchez Cotán's inventory—a picture of fruits with the duck and three other birds ("un lienzo de frutas adonde esta el anade y otros tres pajaros")—makes it clear that the one in this picture was taken from the picture on panel.

The practice of "cutting and pasting," or of copying motifs from one picture to another, and even of repeating whole compositions in the development of new ones, remains puzzling and seems to undermine the rationale of still life as a painting made *ad vivum* and as a direct response to arrangements in front of artists. The notion that Sánchez Cotán would not have always painted from life is all the more surprising given that his production was so deliberately limited. However, the practice of recycling motifs among pictures was common among the earliest painters of still lifes and it remained a standard recourse in the production of such works by later artists.[23] It was common practice too in the world of natural history, where images of plants and animals were copied and recycled from one album to another.[24] If the motifs were observed directly from nature, then the same claim could be made that subsequent iterations of it were painted *ad vivum*.[25] Indeed, how could viewers tell from the pictures whether or not the images recorded a direct encounter with the real thing? The important point here was that the things looked lifelike.

The relationship between *Still Life with Quince, Cabbage, Melon, and Cucumber* and *Still Life with Game Fowl* (see fig. 3) in terms of their making remains unclear, at least to the average viewer, until technical research clarifies this.[26] In keeping, perhaps, with a reprise of already painted elements, there is a degree of overstatement of artistic effects to be seen in the Chicago painting vis-à-vis its counterpart in San Diego. The veins of the cabbage and lit edges of the quince are described in more emphatic

detail. The skin of the melon is painted in a more intense green and its surface pattern is more conspicuous. There are a greater number of loose hairs on the strings supporting the quince and the cabbage. A greater density of brushwork characterizes the modeling of the cabbage, although, in contrast, the handling is more summary in the interior of the melon and the skin of the cucumber. A greater insistence on illusionism has caused the artist to move the melon to the edge of the window frame; now four motifs appear to overlap this plane. Did Sánchez Cotán paint the fuller composition first and then purge it of elements in the reprise, or was it the other way around? There is, perhaps, a certain logic in copying and enriching the more austere prototype by adding the chayote fruit—discussed below—and the sequence of hanging fowl, a roller, turtle dove, a bustard, and a mallard duck, arranged in an elegant counter-curve to the fruits. These birds enhance the illusionistic power of the picture. They all appear to hang in the same plane as the melon and quince, outside the window frame and in the viewer's space; the feet of the bustard just overlap the contour of the melon and the mallard duck casts a shadow on the window jamb.[27] Assuming that one picture was painted first, rather than the two works being painted simultaneously, does it make sense to speak of a prime version and a "copy"? Might it be more accurate to speak of two originals, since the artist himself created a new invention by interpreting one of his own works? This kind of limited variation of his own still lifes, paradoxically, can even be said to have reinforced their uniqueness.

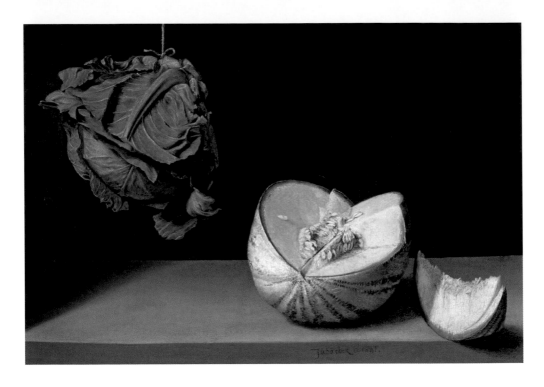

The use of tracings would have been the likely means of transferral of the motifs from the San Diego still life to the composition now in Chicago. The outlines of the motif would be traced by means of a semi-transparent piece of paper, then a 1:1 template made from this, being a cutout shape which follows the outlines of the tracing and which can be drawn around to transfer the motif into the new work. Details could be painted in from the actual prototype before the artist.[28] Comparison of the individual motifs found in both pictures—quince, cabbage, melon, and cucumber—showed that these correspond in size and shape. Moreover, the quince and the cabbage occupy

Fig. 8. Juan Sánchez Cotán, *Still Life with Quince, Cabbage, Melon, and Cucumber* (detail), c. 1602. San Diego Museum of Art. See also fig. 1.

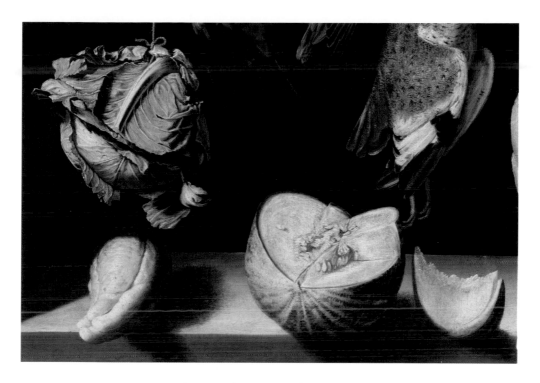

the same locations relative to one another in both works,
which suggests that a template existed that included both
motifs (figs. 8 and 9). It does not appear that a complete
cartoon existed to transfer the whole composition from
one picture to another, but that local templates were likely
used. This procedure mirrored the artist's practice of com-
posing his works from individually observed elements.
While an overlay of the two compositions shows that
the quince and cabbage corresponded in terms of their
location, the other motifs do not. Indeed, the use of dis-
creet templates for the melon, melon slice, and cucumber
would have allowed the artist to change the location of the

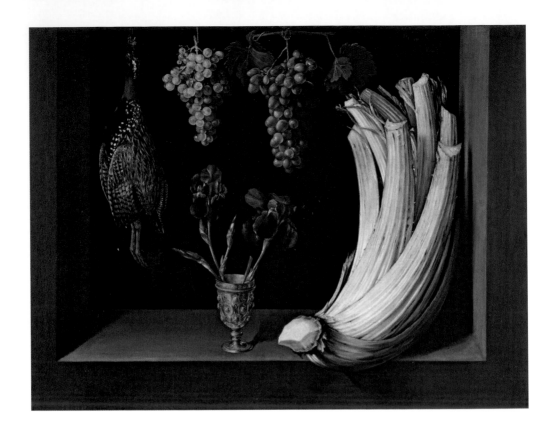

melon, which overlaps the front edge of the window frame in the Chicago picture. X-radiography shows that a complete cucumber does not underlie the duck in the Chicago painting, but that the visible parts of this vegetable have been painted around the bird. This might suggest, therefore, that it has been extrapolated from this vegetable in San Diego.

Felipe Ramírez's *Still Life with Cardoon, Francolin, Grapes, and Irises* (fig. 10) constitutes an "homage" to

Fig. 10. Felipe Ramírez (Spanish, d. 1631), *Still Life with Cardoon, Francolin, Grapes, and Irises*, 1628. Oil on canvas, 28 × 36 ¼ in. (71 × 92 cm). Museo Nacional del Prado, Madrid.

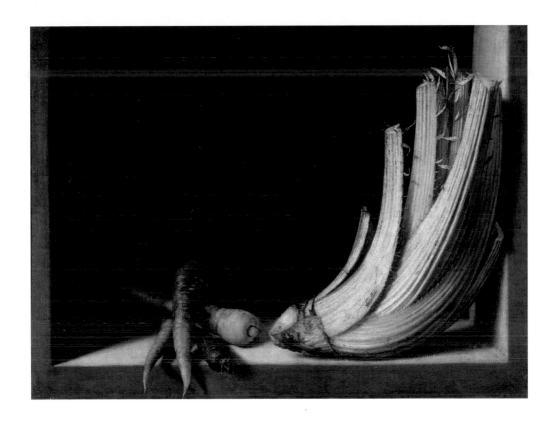

Fig. 11. Juan Sánchez Cotán (Spanish, 1560–1627), *Still Life with Cardoon and Carrots (Thistle Still Life)*, between 1603 and 1626. Museo de Bellas Artes, Granada. See also fig. 7.

Sánchez Cotán in the year of his death.[29] The cardoon and francolin in the picture were evidently traced and copied from *Still Life with Cardoon and Carrots* (figs. 7 and 11).[30] This cardoon is also the same as Sánchez Cotán's cardoon in *Still Life with Game Fowl*, which is referred to as "the" cardoon (as noted above) and which, it seems, generated all other images of it. Ramírez inserted central elements of his own in the picture painted in the style of Sánchez Cotán, and signed and dated the work as his own.

NATURE AND ART

The attentive, high-definition visual description of the observed forms, colors, and surfaces of foodstuffs was an expectation and a convention in this mimetic category of painting. The discourses on art of the time emphasize that this required a high degree of technical proficiency.[31] The main goal that underpinned still-life painting was the image as an objective, high-fidelity "copy" of nature, as a simulacrum of the real thing.[32] An entry in the inventory of the important collection of the Condestable de Castilla from the beginning of the seventeenth century described the fruit in a still-life painting as "counterfeited after nature," a term that set a premium on the accuracy of the representation of the real object.[33] As noted at the beginning of this essay, this is the reason why Sánchez Cotán and others signed their still lifes and why they were admired by contemporaries. Sánchez Cotán's close observation of actual things—at some critical point in the painting process—would have allowed him to claim that his paintings were made following nature. For example, he offers distinct studies of cardoons in at least three of his still lifes.[34] On each occasion, the artist has carefully registered individual thorns and the blemishes on their skins (fig. 12). In the picture exhibited here, this meticulous

Fig. 12. Juan Sánchez Cotán, *Still Life with Game, Vegetables, and Fruit* (detail), 1602. Museo del Prado. See also fig. 4.

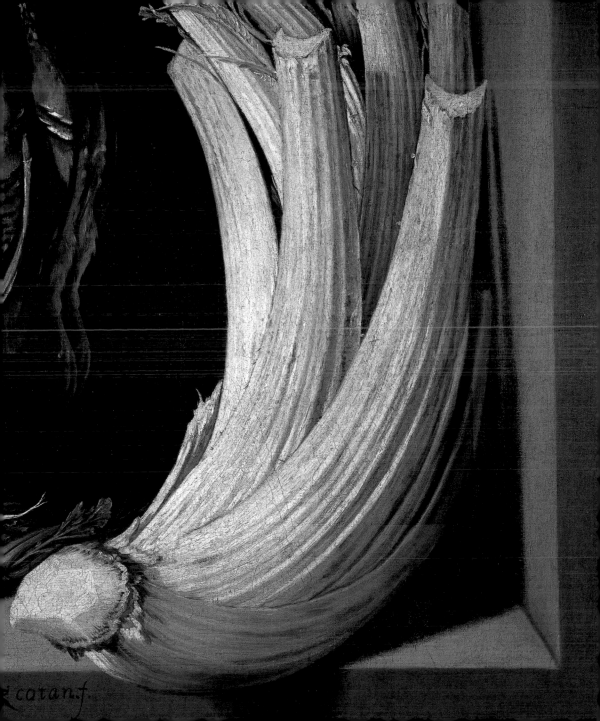

descriptive approach is evident, for instance, in the curling leaves of the cabbage, the loose threads of the strings, and the studied accident of the fall of a sticky melon pip. The attention paid to the imperfections on the skin of the quince—and the brown spots on its leaf—contrast with the idealized epidermis of figures in his narrative pictures. A bad spot represented on one of the apples in *Still Life with Game, Vegetables, and Fruit* (fig. 13) was uncovered in conservation, having been painted over in a previous restoration meant as an "improvement" of the painting. This blemish is a rhetorical device, which gave authority to the idea of the picture as a faithful, unadulterated copy of *that* particular apple as it is (rather than as it should be in an ideal world).

The emergence of still-life painting and its raison d'etre of the visual description of flora and fauna has been seen alongside the practices of empirical observation in natural philosophy, which characterized the scientific revolution of the sixteenth century.[35] Still lifes' condition as representations of the natural world by artistic means explains their early appearance in collectors' cabinets, spaces for the study of nature in which natural objects and manufactured things coexisted, and in northern European paintings of these collections.[36] The pictures on the walls of the library of the aforementioned Condestable de Castilla in 1613 included two fruit still lifes on panel.[37] In 1599 a still life hung in the "estudio y biblioteca" of Cardinal Pedro García de Loaysa, canon of Toledo cathedral, the itemization of whose foodstuffs in the inventory entry sounds like it could be by Sánchez Cotán.[38]

Fig. 13. Juan Sánchez Cotán, *Still Life with Game, Vegetables, and Fruit* (detail), 1602. Museo del Prado. See also fig. 4.

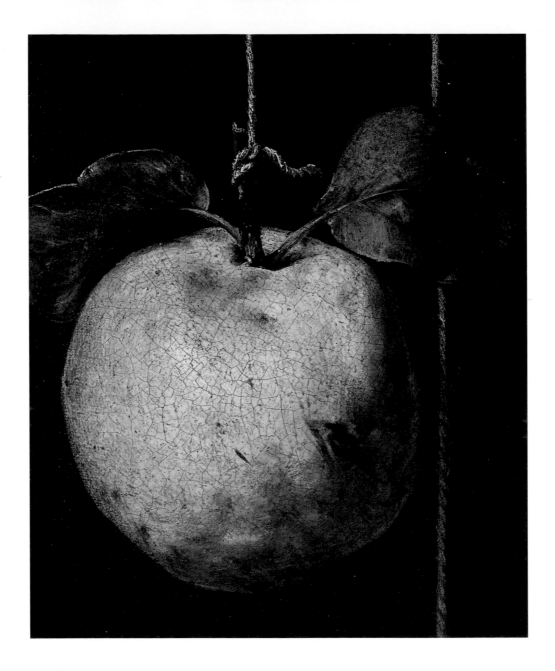

While still-life painting and natural history illustration might share subject matter and the goal of naturalistic accuracy, their functions and their conventions of representation and of viewing are different. Natural history illustrations were usually rendered in watercolor on paper or vellum and were often bound in albums, which made for a serial, cumulative experience, though they could and were framed and hung on walls.[39] Sánchez Cotán's still-life paintings were framed works of art intended to be seen hanging on walls of residences and in picture collections of the time. The genre adheres to aesthetic conventions established from its inception, some of which have been already mentioned. The viewpoints are usually at eye level, in accordance with the location of the canvas on an easel, and take account of a spectator looking at the painting hanging on a wall. Everyday foodstuffs are presented in compositions that are far from the ways in which they would have actually appeared on tables and in larders, and which denote the performance as an essentially artistic one. A generalized use of dark backgrounds in early pictures enhanced the clarity of the contours and shapes of things, while directed lighting created the illusion of three dimensionality. And this is to say nothing of the exploitation of the properties of oil paint to recreate their colors and textures. In natural history illustration the botanist needed to guide the artist in order that the aesthetic values did not compromise scientific objectives.[40] An overly "artistic" representation might limit the amount of botanical information provided. Foreshortened objects, for instance,

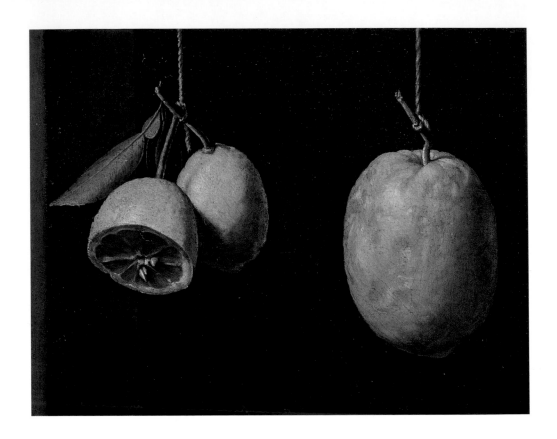

do not allow their characteristic form or their approximate
size to be judged. The absence of flowers and roots from
many of the fruits and vegetables represented in Sánchez
Cotán's still lifes is another significant lack of informa-
tion.[41] The spaces of early still-life paintings in other parts
of Europe accommodated insects and other small creatures,
as do the flower pieces of Jan Brueghel, though it has to be
said that Sánchez Cotán's works do not show any interest
in this "microscopic" aspect of the world—not even the

painted flies that became a rhetorical commonplace in still life to draw attention to the imagined freshness of the fruit (assuming that these have not been removed in past cleanings of pictures).

Having said this, the divide between art and natural history was not rigid during the period.[42] *Still Life with Quince, Cabbage, Melon, and Cucumber*, for instance, still communicates knowledge to the interested viewer about the relative size of the fruits and vegetables, their forms, colors, and surface features.[43] It shows the outside and the interior of the melon and its seeds. In another picture by the artist, an orange is shown in a whole state and in a slice; two kinds of lemons are represented, and hanging from a string is a whole lemon and a halved lemon, whose pips are prominent (fig. 14). Indeed, a whole range of manufactured objects can be seen in the same terms, such as the Faenza trompe l'oeil ceramic fruit plates that were collected from the sixteenth century.[44]

Just as still-life paintings can contain scientifically useful information, so scientific drawings can be beautiful. A sixteenth-century Spanish album in the library of the Escorial is a good example of this crossover between art and science.[45] Although produced as a natural history album, the images incorporate artistic elements and staging procedures that are more common to still-life paintings (figs. 15–18). The ninety-one full-page illustrations in watercolor and gouache on paper are by a single, unidentified hand. The marked wear to the lower right corner of all of the pages

Fig. 14. Juan Sánchez Cotán, *Still Life with Fruits and Vegetables* (detail), c. 1602. Juan Abelló Collection. See also fig. 5.

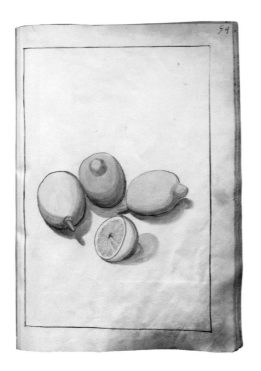

show that the album was well used over time. It comprises mostly images of birds, often accompanied by butterflies, and common or garden fruits and vegetables; only three are of flowers and there are a number of assorted animals at the end of the book, including a parrot, tortoise, lizard, bat, and owls. It is highly unlikely that all—if any—of the images were made from life. The simplified drawings show a distinct linearity in representing the shapes of plants and animals, with close attention paid to the details and color. Foreshortening is used in their representation; some birds turn outwards from the page. Forms are partially modeled

Fig. 15. Drawing of lemons from a natural history album. Watercolor and gouache on paper. Biblioteca de El Escorial, 28.II.3, fol. 54.

Fig. 16. Drawing of melon from a natural history album. Watercolor and gouache on paper. Biblioteca de El Escorial, 28.II.3, fol. 51.

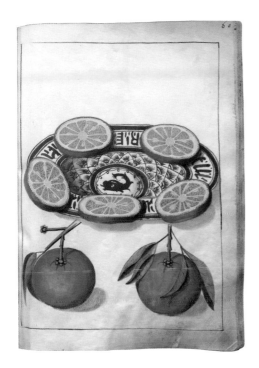

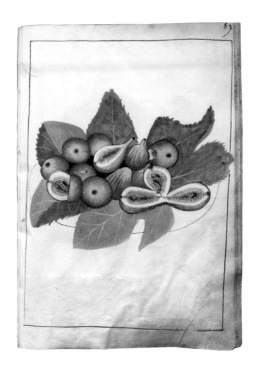

Fig. 17. Drawing of sweet oranges from a natural history album. Watercolor and gouache on paper. Biblioteca de El Escorial, 28.II.3, fol. 60.

Fig. 18. Drawing of figs from a natural history album. Watercolor and gouache on paper. Biblioteca de El Escorial, 28.II.3, fol. 69.

in light and shade and cast short, attached shadows onto the page. Some birds are shown in nondescript linear trees, and some fruits are shown on the branch. Two images depict fruit on plates; one presents sweet Valencian oranges on a local Manises plate (fig. 17). Figs are represented bursting open on a bed of fig leaves, just as they would have been presented at table (fig. 18). In another image of green figs on a plate, the runny red lake expresses the juicy inside of the fruit. The gustatory appeal of these images of everyday comestibles is undeniable.

Sánchez Cotán's still lifes also represent common fruits and vegetables. However, *Still Life with Game Fowl* includes a surprise; in the right-hand corner of the window frame there is a chayote fruit or a climbing cucurbit of the smooth variety from Mexico (fig. 19). The comparative juxtaposition in the picture with the cucumber doubtless is intentional. Its foreshortening and modeling gives the impression that it was painted from an actual fruit. Assuming that this is so, perhaps its novelty piqued the artist's curiosity. But it is unlikely that many viewers in Toledo in 1600 knew what it was, how it was prepared, or what it tasted like. Their lack of knowledge aside, a general unfamiliarity with this object in modern times meant that it was only formally identified in the art-historical literature in 1992.[46] Perhaps this representation of New World flora from the Spanish colonies provided a talking point for interested parties.[47]

Fig. 19. Juan Sánchez Cotán, *Still Life with Game Fowl*, (detail), 1600–1603. The Art Institute of Chicago. See also fig. 3.

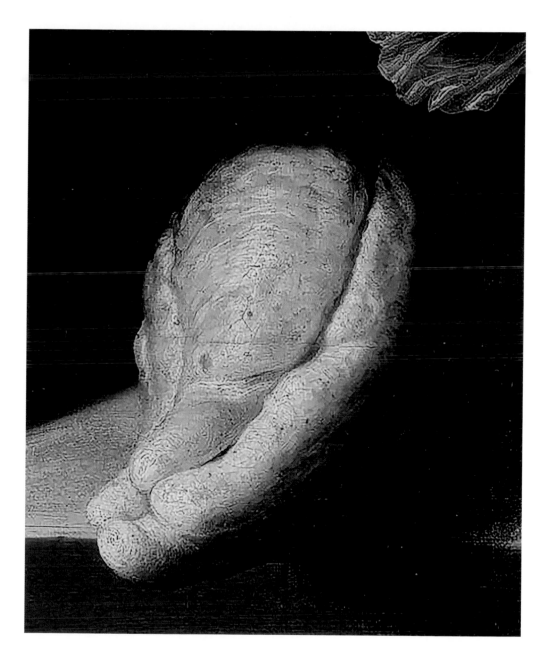

SÁNCHEZ COTÁN AND THE ORIGINS OF STILL LIFE IN SPAIN

Sánchez Cotán's still lifes seem to appear out of nowhere. No direct precedent has been identified in the early-modern history of the genre for his particular compositional format of a window frame with hanging elements.[48] This could mean, of course, that one did not exist; after all, some artists do new things some of the time. Having said that, Sánchez Cotán did not work in a vacuum and the artistic context propitious for his invention of these pictures in Spain can be identified.

Francisco Pacheco's *Arte de la pintura* (1649) devotes a section to "pintura de frutas" (just after a section on flower paintings) and names two innovators in the field. He says that he remembers seeing "very well-painted" fruit pictures ("lienzos de frutas") by Blas de Prado (c. 1546–1599) in Seville in 1593, when he stopped there en route to Morocco on an embassy of Philip II.[49] In commenting on

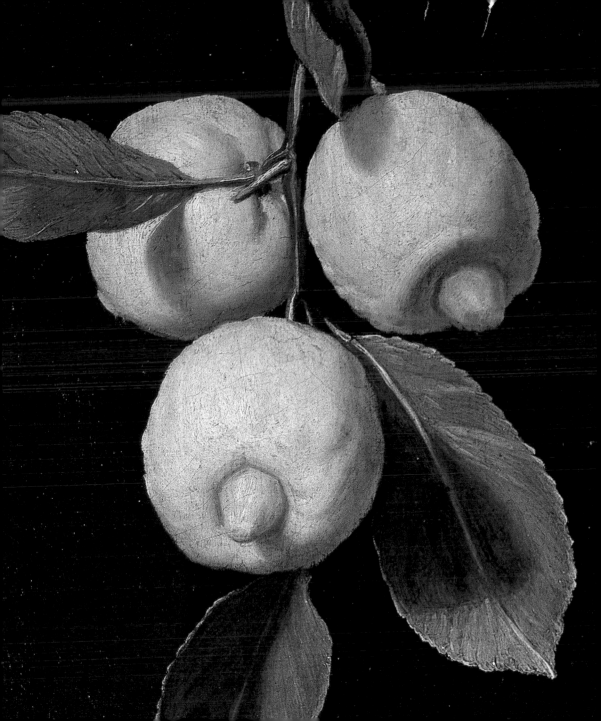

their quality, Pacheco doubtless meant that they looked realistic.[50] If they were for the sultan of Morroco, these painted fruits can be seen in the ancient tradition of food gifts in Mediterranean countries.[51] He goes on to say that Sánchez Cotán, Prado's pupil ("discípulo"), was very famous ("tenía mucha fama") in this genre of painting before entering the Carthusian order.[52] Sánchez Cotán's signatures on his still lifes—and the date on one of them—demonstrate a pride in his achievement in this "new" genre of painting. He may also have painted an independent self-portrait, which was listed as unfinished in his studio in 1603, perhaps wishing to leave his likeness for posterity.[53]

Fruit was the subject matter of the still lifes by Prado that Pacheco saw, although none has been identified today.[54] This choice of subject matter was conditioned by the ancient literary precedents (noted above) which shaped values around the genre. Pieces of fruit represented in a basket, on a plate, or in a bowl or comport are the earliest known typologies of still lifes in Italy. These were painted by artists in Milan (under the control of the Spanish viceroys), such as Fede Galizia (1578–1630), who specialized in exquisite small-format still lifes (fig. 20). Some of these may have been imported into Spain at an early date.[55]

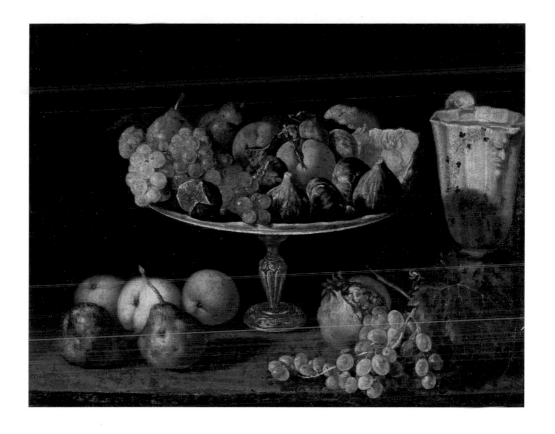

Fig. 20. Fede Galizia (Italian, 1578–1630), *Pedestal Plate with Southern Fruit*, 1601. Oil on canvas, 19 1/2 × 26 in. (49.6 × 66 cm). National Museum, Warsaw.

Prado's idealizing style is the result of his study of the collections of Italian painting at the Escorial, which Sánchez Cotán knew well too, and both doubtless learned from the illusionism of the fresco cycles.[56] This representational mode defines the religious figures in his altarpiece of the Virgin and Child with Alonso de Villegas from 1589 (Madrid, Museo Nacional del Prado), while the donor portrait is in a more realistic, descriptive manner. This kind of decorum of style—to be seen too in Sánchez

Cotán's figure paintings—also operated in the still life details of his religious works. Mary Magdalene's gold ointment jar in the right foreground of an altarpiece of the Pietà (c. 1570–80) shows his awareness of the artistic potential of such elements.[57] It is a tour de force of observation and illusionism, as exemplified by the shadows cast by the different elements of its elaborate decoration. Artists routinely inserted realistic still-life details in paintings with figures, and painters in Toledo were no exception.[58] The crucial difference is that Prado made the conceptual leap to independent pictures of them in a new category of painting we call the still life.

The master-pupil relationship between Prado and Sánchez Cotán described by Pacheco has not been verified by an apprenticeship contract. The artists may even have been closer in age than is currently believed.[59] Sánchez Cotán, born in 1560, could have painted his first still lifes in the 1580s. Existing documentation suggests a close professional relationship between them. In 1603, Sánchez Cotán had in his possession a book of Prado's drawings and something listed as "a book of Blas de Prado of painting" ("un libro de Blas de Prado de pintura"). Whether this was a printed volume owned by Prado or was something he had

written on the art of painting, its existence would appear to indicate intellectual interests beyond the mere practice of their profession. Having said this, no personal library is registered in Sánchez Cotán's inventory.[60] He could, of course, have accessed reading by other means, but the absence of books at this point in his career should be borne in mind in attempts to construct him as a humanist painter. Their common interest in still life painting is implied in a document of March 23, 1600, concerning money owed to Prado's heirs by a silversmith, Gonzalo González; the latter leaves out of their agreement "una pintura de unas frutas," which he says he had already handed over to Sánchez Cotán in Toledo.[61] The datum is, unfortunately, ambiguous: it does not reveal whether this was a still life painting by Blas de Prado that belonged to or was inherited by Sánchez Cotán or whether it was one of Sánchez Cotán's own.

In his aforementioned account of still life in Spain, Pacheco refers to a local example of fruit painting in the festoons painted by Antonio Mohedano (c. 1561–1626), probably in fresco, in the cloister of the convent of Saint Francis in Seville (now destroyed).[62] Mohedano also painted fruit still lifes; a series of fourteen pictures of baskets of fruit are recorded in a noble collection at the

beginning of the century.[63] The commonality between decorative frescoes of festoons and the still-life easel painting depended on the idea of the imitation of nature via the subject matter of fruit and flowers. Mohedano's festoons likely derived from the kind of *all'antica* decoration known as grotesques, which Raphael and his assistant Giovanni da Udine revived from the study of ancient remains in Rome.[64] In the garden loggia of the Farnesina villa in Rome, Udine depicted a fictive pergola richly appointed with fruits, vegetables, and flowers—many from the New World—which rivals the real garden beyond.[65] The Sala de Frutas in the imperial apartments at the Alhambra (Granada) is an iteration of this language; its coffered ceiling is decorated with panels showing fictive bunches of fruit and vegetables, which also bring the garden "indoors."[66] The illusionistic presentation of fruit and flowers in such decorative schemes is an important dimension of the kind of naturalism implicit in the stories of mimesis from antiquity—invoked by the insistent presence of birds—which was not lost on still-life painters.

One of the most impressive and prestigious cycles of illusionistic decoration is local: the frescoes by Luis de Medina on the walls of the anteroom of the Sala Capitular (chapter room) of Toledo Cathedral painted during the archbishopric of Cardinal Francisco Jiménez de Cisneros (1495–1517).[67] This fictive decoration

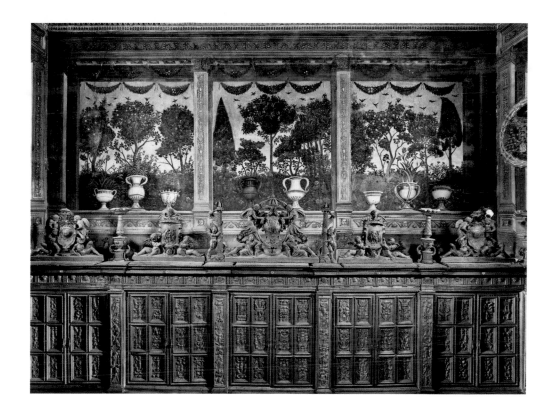

Fig. 21. Fresco of the
anteroom of the Sala
Capitular of Toledo
Cathedral.

comprises a lower story of maiolica vases with fruit trees
and flowers in a recessed space and a second story of a
loggia giving onto a garden with fruit trees and with mai-
olica vases of fruit trees and flowers. Swags of fruit hang
from the roof of the loggia and birds have been attract-
ed by the fruit (fig. 21). The interior of the Mudejar
entrance door is painted with a fictive door frame and the
entrance to the chapter room is decorated with embossed
tondi suspended by cords with the arms of Cardinal
Cisneros flanked by those of Diego López de Ayala,

canon *obrero* of the cathedral.[68] Beside the door, there is a fictive niche with a trompe l'oeil vase of carnations casting a strong contour shadow (fig. 22).[69]

The decoration wraps around the four walls of the room and the linear perspective is projected from a central point on the floor. Although the overpowering wooden cabinets in the room—placed there in the mid-sixteenth century and 1780—compromise the intended effect, it is still thrilling to experience the illusion of the wall having been painted away. Doubtless, Sánchez Cotán studied the frescoes closely and would have had ample opportunity to do so in 1586 when Blas de Prado restored the paintings of the chapter room.[70] Prado himself was competent in the art of perspective, as can be seen in the illusionistic fresco of the Pentecost in the dome of the chapel of the villa of Cardinal Quiroga.[71] Sánchez Cotán too was deeply interested in this art as an illusionistic recourse. One of his most celebrated paintings in the Charterhouse (Cartuja) of Granada is the fictive altarpiece of Saints Peter and Paul.[72] And this is to say nothing, of course, of the effective perspectival expedient of the window frame in his still life paintings.

Fig. 22. Fresco of the anteroom of the Sala Capitular of Toledo Cathedral.

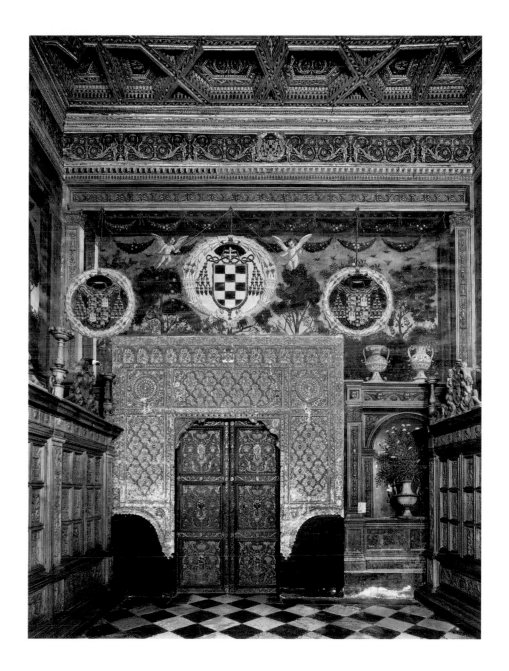

SLOW FOOD

What did *Still Life with Quince, Cabbage, Melon, and Cucumber* mean to viewers at the time? While any readings of the picture today should not be confused with the artist's intentions, which we cannot know, a number of plausible interpretations can be put forward. This essay has emphasized so far that a culture of representational virtuosity framed expectations in still life paintings. One way in which viewers could have understood the subject matter of still lifes was through religion, since the natural world was conceptualized as something created by a benign God.[73] However, some scholars have insisted on vague spiritual and "mystical" values in Sánchez Cotán's still lifes based on suppositions related to his subsequent entry into the Carthusian religious order. One critic speaks of the monastic and "anorexic" qualities of Sánchez Cotán's still lifes and characterizes these as works that appeal to the mind and spirit, rather than the bodily senses.[74] An often-cited basis for this kind of interpretation is the artist's supposed piety.

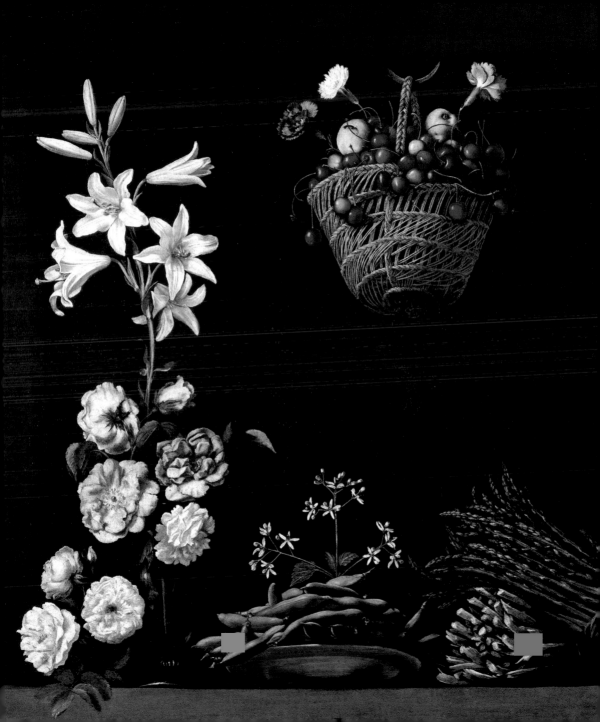

He does appear to have undergone some kind of religious awakening, which caused him to leave behind his career in Toledo and to join the Carthusian order in 1603. The circumstances of this decision are unknown and the choice of the Carthusian order is puzzling as there is no Charterhouse in Toledo. He enjoyed a reputation in the Charterhouse of Granada as a pious member of the order; he even had a saintly reputation there and tradition has it that the Virgin Mary sat for her "portrait" in his painting of St. Ildefonso receiving the chasuble from the Virgin.[75] It is worth remembering, however, that he professed as a lay brother (*lego*). Lay brothers were dedicated to serving the monastery in all manner of practical duties and were able to interact with the secular world.[76] In the case of Sánchez Cotán, his service included painting and he painted altarpieces and a famous series of Carthusian histories for the monastery. He was, therefore, not one of the friars who devoted themselves to prayer and to the contemplative spiritual life.

Only one still life known today, *Still Life with Cardoon and Carrots* (fig. 7), appears to date from his Granadan years. Because it was found at the Charterhouse, scholars have interpreted it in relation to monastic austerity and the Carthusian vegetarian diet, even though the cardoon— here one of the rose variety—was, as we have seen, a leitmotif.[77] However, *Still Life with Quince, Cabbage, Melon, and Cucumber* was painted in Toledo before Sánchez Cotán joined the order and it would seem methodologically lax to insist on a blanket reading of this and other still lifes

from this point in his career. Such interpretations draw on modern stereotypes of Spanish religiosity, rather than convincing biographical evidence.[78] How, for instance, would the carnality of the game birds in *Still Life with Game Fowl* (fig. 23), a work also listed in his inventory of 1603, fit into this model?

It is true that *Still Life with Quince, Cabbage, Melon, and Cucumber* presents foodstuffs as a primarily aesthetic experience. There are no accoutrements or paraphernalia of the market, the kitchen, or the table to be seen here, merely common or garden comestibles. The window frame is not represented as having any utilitarian function as a larder or cooling space.[79] The traditionally "higher" sense of sight has won out in the historiography of the picture over the "lower" senses concerned with the body, though prosaic as it may seem, it is not difficult to imagine that viewers of the time would have shown some degree of interest in the represented objects as food.[80] For people in the past, fruits and vegetables were available when in season. At a time when food was grown locally, some viewers would have known the complexities of its cultivation, itself a vernacular science.[81] The seasons provided a traditional conceptual framework for images of nature. This structures the taxonomy of an early Spanish series of twelve still lifes in which the name of the month is inscribed on each and the pictures represent the foodstuffs appropriate to this time from a high viewpoint, which maximizes visual information.[82] A general unfamiliarity with some foodstuffs among viewers

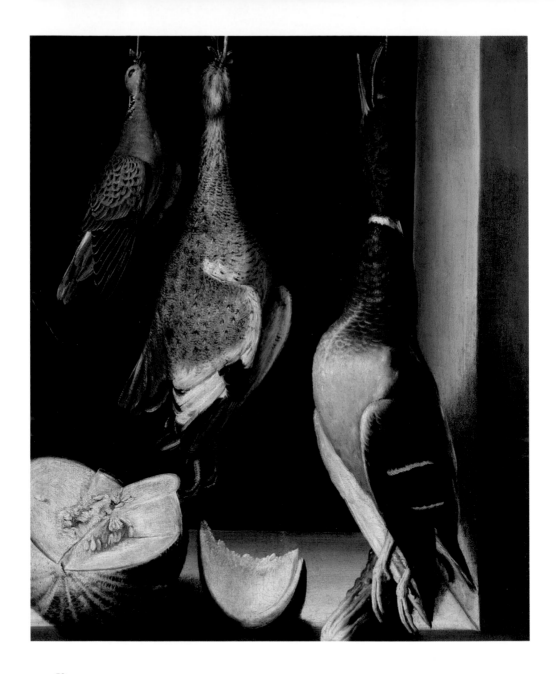

in the more recent past has also led to an undue emphasis on the "abstract" nature of their treatment. The cardoon was mistaken for celery in some of the English-language literature of the past century, although it remains a staple in the winter months and on the Christmas table in Castile. There is no doubt that Sánchez Cotán liked the form of the cardoon and exploited its compositional potential in his still lifes, but it is also food. Indeed, the familiarity of the repeated motifs was important; knowing the real thing allowed viewers to enjoy all the more its lifelike representation. In fact, Sánchez Cotán's favoring of foods that would be at home in the kitchen or on a table suggests that consumption is implied. Vegetables are washed, topped, and tailed and ready for cooking in his pictures, as if they have come from the market—the cardoon being the most obvious example. In one picture—presently known only via a photograph—a string of garlic hangs just as it would in the larder or kitchen, while peeled chestnuts are offered in a glass tazza.[83] Goldfinches on a bamboo spit prepared for the oven appear in *Still Life with Game, Vegetables, and Fruit* (fig. 24). Another still life, known via copies, featured a basket of apricots and a basket of cherries decorated with carnations as it might be presented at table.[84] This motif recurs in a picture that includes asparagus and peas (fig. 6).[85] The everyday represented objects, moreover, would have engaged viewers' senses of taste, smell, and touch (and science confirms that representations stimulate senses like the real thing).[86] Quinces are a fragrant fruit and are

Fig. 23. Juan Sánchez Cotán, *Still Life with Game Fowl* (detail), 1600–1603. The Art Institute of Chicago. See also fig. 3.

placed in drawers to perfume linen and clothes. Despite Sánchez Cotán's rather dry treatment of the interiors of fruits, a viewer admiring *Still Life with Quince, Cabbage, Melon, and Cucumber* cannot help but recall with pleasure the cooling sweetness of melon: surely this is the reason it has been cut open and a prepared slice offered to the viewer (fig. 25). And where is the rest of it? Most probably it has been eaten by someone—the artist, the viewer—in a play on the story of Zeuxis's birds.

Still Life with Quince, Cabbage, Melon, and Cucumber has come to define the aesthetic of Sánchez Cotán's still lifes, even though it is, comparatively speaking, an exception. The seemingly overloaded composition of *Still Life with Game Fowl* in Chicago approximates so little to this standard of austerity that it was long considered to be by an imitator.[87] Contemporaries, however, would have seen nothing unusual in the game birds being hung up in this way to age and preserve their meat. It is likely that they could identify the birds. The Toledan country-side is a prime location for hunting partridge in season; many would know these as prey and would be reminded of the enjoyment of their pursuit, to say nothing of their consumption at table. More would know them as food and even know their price as commodities in the mar-ket square; in this regard, perhaps the duck still means most to viewers today (even if we are not used to seeing food in its "natural" state). People who consumed these game birds may have done so with the knowledge of the

Fig. 24. Juan Sánchez Cotán, *Still Life with Game, Vegetables, and Fruit* (detail), 1602. Museo del Prado. See also fig. 4.

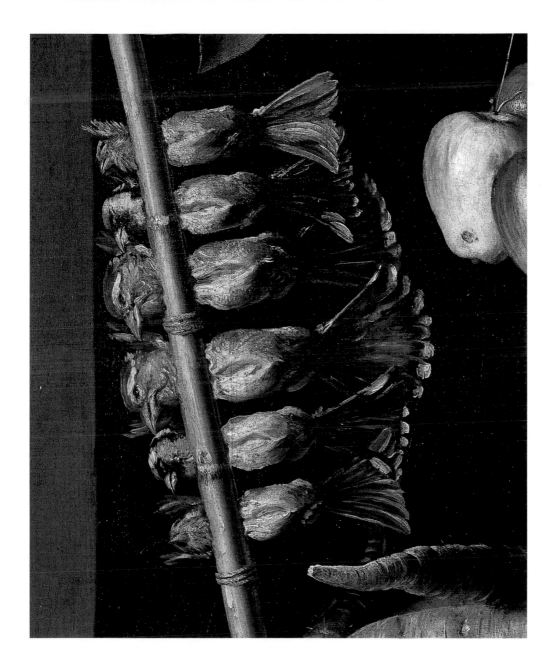

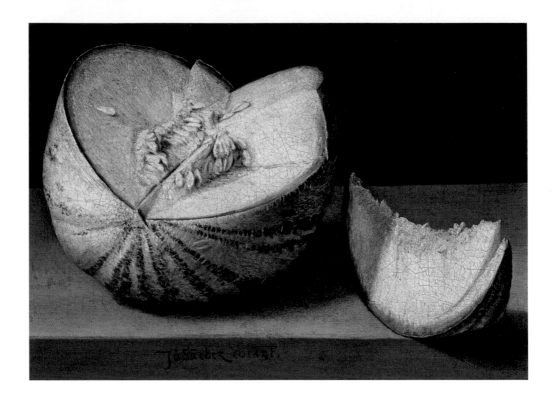

perceived hierarchy of classes of foodstuffs. The most low-ly foods were root vegetables, which were located in the earth and were appropriate for the lower classes, while the highest were birds who inhabited the element of the air and were appropriate for the delicate palates of the elites.[88] An ironic reference to flight is hanging them in the air as "still" life.

Fig. 25. Juan Sánchez Cotán, *Still Life with Quince, Cabbage, Melon, and Cucumber* (detail), c. 1602. San Diego Museum of Art. See also fig. 1.

The properties of the foods themselves in health regimes of the time would also be a point of access to Sánchez Cotán's paintings. In this context, the generally heartening aspect of still lifes—and other nature themes, such as landscape painting—is also relevant. The way in which such paintings could turn viewers' imaginations towards pleasant recollections, keeping at bay the melancholy that provoked diseases, has led some to see in them a therapeutic power. In this respect, paintings of fruit and flowers enjoyed certain advantages over the real thing; they concentrated and filtered reality and, of course, could be returned to again and again.[89]

The history of the display and collecting of Sánchez Cotán's still lifes in the past—where this can be known—tells us something about the ways in which they were "read" and valued. In his testament Sánchez Cotán authorized his executors Juan de Salazar and Diego de Valdivieso to sell his possessions at auction, including the still lifes and other pictures listed in his inventory. This sale, if it ocurred, has yet to be documented. Salazar died in 1604 and it is unclear how this affected the estate settlement. However, indirect evidence shows that a number of the still lifes listed in Sánchez Cotán's studio at this time found their way into the collection of Cardinal Bernardo de Sandoval y Rojas (d. 1618), archbishop of Toledo (though not, it seems, *Still Life with Quince, Cabbage, Melon, and Cucumber*). The royal accounts detail a 1619 payment to Juan van der Hamen for a painting, which has recently come to light and was intended to

complete a series of six still lifes hanging over the windows of the Galería del Mediodía (South Gallery) in the king's quarters of the royal hunting lodge of El Pardo, just outside Madrid—the other five paintings having been bought from the estate sale in Madrid of Sandoval y Rojas.[90] Study of the inventories of El Pardo show that these were works by Sánchez Cotán or after the artist.[91] It is likely that the works had decorated the cardinal's villa in Madrid, the Huerta de Sandoval.[92] Given the relative rarity of still lifes on the market at this time and the small number of paintings by Sánchez Cotán available, it was a remarkable act of collecting to have assembled this group of works in these locations and suggests that the cardinal was an enthusiastic admirer of the works of the artist.

The cryptic entries for the five compositions by Sánchez Cotán in the inventory of the South Gallery of the main floor of El Pardo in 1653 call them all "fruteros" and note a salient motif in each of the compositions.[93] In the order given in this document, the first picture was said to include a cardoon.[94] Perhaps this was one of the copies the artist made of *Still Life with Game, Vegetables, and Fruit* (see fig. 4), which in 1603 belonged to Juan de Salazar, or even the original. The next still life represented a basket of apricots.[95] This is a composition by Sánchez Cotán that was listed in his inventory as well—identifiable by its hanging basket of cherries—and that is only known today via copies. The third still life was described as a picture with an open melon.[96] This is the Chicago *Still*

Life with Game Fowl (see fig. 3), since the number "145," which was painted on it, corresponds to the number and entry in the 1654 inventory of El Pardo.[97] When it was listed in the artist's inventory in 1603 it was said to belong to Diego de Valdivieso, from whom it must have been acquired by Sandoval by means currently unknown. A fourth still life represented a tray of figs and grapes, which is currently unknown.[98] This might be the picture listed in the artist's studio as a painting of a small basket of grapes belonging to Diego de Valdivieso and, if so, would have been acquired by the cardinal, along with the Chicago picture, from his collection.[99] The fifth picture was said to represent two onions and relates to a composition that was listed in the artist's inventory and is known today in photographs.[100]

The still lifes are recorded in situ in El Pardo up to the end of the seventeenth century.[101] Their location during the eighteenth century is unclear at present, as are the precise details of the dispersal of the paintings during the Napoleonic period.[102] The Chicago picture was taken by Joseph Bonaparte to France in 1813 and with him to America in 1815.[103] This still life has long been confused with *Still Life with Quince, Cabbage, Melon, and Cucumber* in the art-historical literature. In fact, the San Diego still life did not hang among the group inventoried at El Pardo. Its provenance after 1603 and the date of its arrival in America remains unclear.[104]

Whatever Sánchez Cotán intended in his still lifes, their meanings inevitably changed and they acquired new roles and new audiences when they left his studio. That they should have come to decorate Cardinal Sandoval's recreational "Huerta" and transitioned to El Pardo palace, dedicated to hunting, was due to their subject matter. The natural world cast in the still relatively novel form of a still-life painting fitted easily into a long established mode of decoration for villas dedicated to recreation, in which hunting had a primordial role.[105] The apparently marginal location of the works in El Pardo—hanging over the windows of the gallery—actually connected them to nature, since these windows looked out across the landscape. This south-facing gallery was warm in November and December, when the lodge was used for hunting, and some of the motifs—the fowl in the painting in Chicago, for instance—would have been hunted there.[106] An annotation by the court architect in a plan of the main floor of the palace calls this the "gallery used for eating" ("galería para comer").[107] This made the still lifes all the more appropriate for this context in that the act of dining by the king and his intimates was accompanied by representations of foodstuffs.

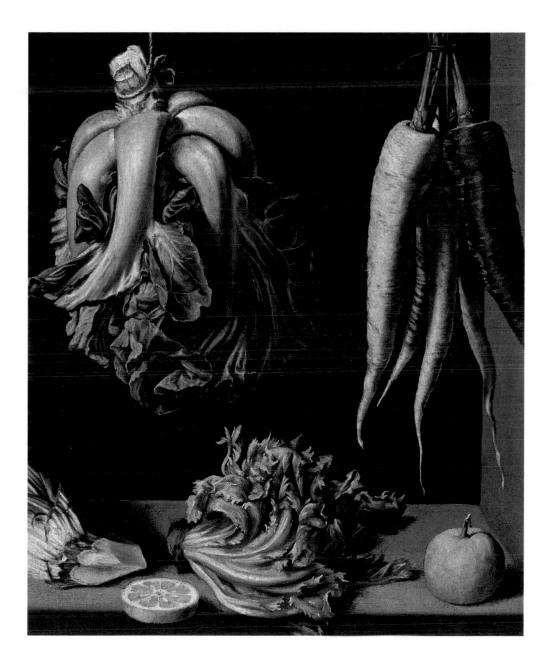

TWENTIETH-CENTURY PERCEPTIONS— MYSTICISM AND MODERNITY

Still Life with Quince, Cabbage, Melon, and Cucumber is one of the best-known and most widely reproduced still lifes of the Spanish school. It was published as a black-and-white photograph by Martin Soria in 1945, the year of its acquisition by the San Diego Museum of Art.[108] Despite being exceptional in many ways, even within the oeuvre of the artist, it came to be perceived as typifying an essentially "Spanish" aesthetic—austere, ordered, dark, religious. Drawing on the erroneous belief that the artist was a Carthusian monk (rather than a lay brother), Soria speaks of Sánchez Cotán's "ascetic idealism and a conscious mystic spirituality" and asserts vague analogies with El Greco and Saint Teresa of Ávila.[109] Consequently, a monastic austerity is perceived in the work and it is characterized as an "invitation to abstinence." The formal and the mystical conjoin in a range of poetic parallels: the "incompleted conic, [is] a question mark into the infinite," the objects are "like notes on a sheet of music, like a hymn to be sung," and, Soria asks, does not the black background "make us realize the value of abstract space as the unknown, the infinite, the eternal in harmony with the traditional tendencies of the Spanish spirit ... to express spiritual yearning for the space beyond, for life everlasting?"

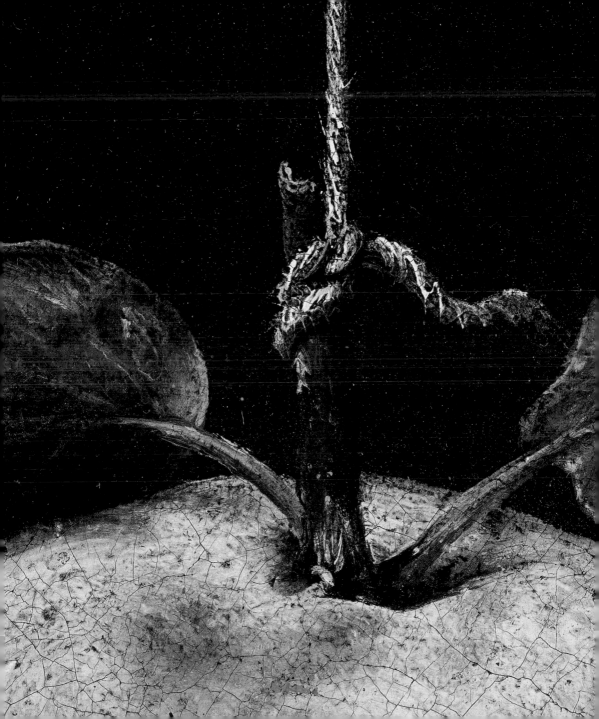

The other famous early Spanish still life in the United States is Francisco de Zurbarán's *Still Life with Lemons, Oranges, and a Rose* (fig. 26), acquired by Norton Simon in 1972 from the Contini-Bonacossi collection. This painting was published in 1926 and first exhibited in Rome in 1930.[110] In a memorable analogy, Soria described the depicted objects as "painted like gifts on the altar of God."[111] Soria, whose scholarship focused on this artist in these years, saw "the most humble and spiritually portentous" works of Sánchez Cotán anticipating the "deep religious piety and ... great humility" of the still lifes of Zurbarán.[112] The perceived kinship of this kind between the artists was expressed in the Zurbarán exhibition in Granada in 1953 organized by María Luisa Caturla, which exhibited the Zurbarán still life along with Sánchez Cotán's *Still Life with Cardoon and Carrots* (see fig. 7).[113]

Recurrent anachronistic assumptions of mysticism and humility thread through the historiography of Spanish still life in twentieth-century scholarship. A parallel treatment can be seen in the case of El Greco in Toledo, whose configuration as a "mystical" artist made him the most "authentic" (*castizo*) of Spanish painters.[114] Thus, Julio Cavestany, in the catalogue published in 1940 to accompany the monumental exhibition on still life in Spain held in Madrid in 1936, insisted on an "ascetic idealism" in Sánchez Cotán's still lifes, which flowed from his Carthusian identity, calling him "Fray" or friar throughout.[115] Over a long career, the Granadan philologist Emilio Orozco Díaz did the most to propogate this

Fig. 26. Francisco de Zurbarán (Spanish, 1598–1664), *Still Life with Lemons, Oranges, and a Rose*, 1633. Oil on canvas, 24 1/2 × 43 1/8 in. (62.2 × 109.5 cm). The Norton Simon Foundation, F.1972.06.P.

idea of Sánchez Cotán. For him, mystical literature was the key to the artist's quintessentially "Spanish," "transcendental" realism; his still lifes are the equivalent of Fray Luis de Granada's view of God's immanence in nature in the first part of his *Introducción del Símbolo de la Fe*.[116] In the influential book on European still-life painting by Charles Sterling, which accompanied a 1952 exhibition held at the Musée de l'Orangerie in Paris, the "humble and mystical" Spanish still life became an internationally established stereotype.[117]

Formalist readings of Sánchez Cotán's still lifes in the last century frequently saw these works through the lens of the "pure" and "authentic" pictorial values of the avant-garde and emphasized their pictorial artifice. Soria described

Still Life with Quince, Cabbage, Melon, and Cucumber as "a mystic poem in the form of a rational exercise of mathematic precision."[118] Based on no real evidence, he interpreted the perceived geometrical order of the composition as "Archimedean."[119] Moreover, the hanging elements were as mesmerizing as Alexander Calder's mobiles; the artist had studied spatial and formal problems like Piet Mondrian, and the metamorphosis of forms across the picture was reminiscent of Salvador Dalí.[120] For August Mayer, Zurbarán's *Still Life with Lemons, Oranges, and a Rose* was "monumental in its simplicity," characterized by an "honesty and deep artistic truth," which gave it "harmony" and made it as "luminous as a work by Cézanne."[121] An apparent emphasis on form and space in these still lifes gave them a "metaphysical" and "spiritual" dimension.[122] A perceived "primitivism" in Zurbarán's paintings was thought to appeal to his monastic patrons, as did the seemingly conscious archaism of Sánchez Cotán.[123] Zurbarán used large areas of pure color and deliberately flouted the rules of perspective in order to "solve exciting problems of spatial relationships" and to stress the picture plane, just like Cézanne and Picasso.[124]

Ideas of Spanish still life as proto-modernist were also colored by realistic painting of the 1920s and 1930s, and some modern painters, in turn, responded to these older works.[125] Salvador Dalí's *Basket of Bread* of 1926—signed in the same year as the publication of the Contini-Bonacossi still life—is an homage to Zurbarán in its sharp lighting and meticulous realism.[126] Roger Fry—an apologist for Cézanne—published a version of the Contini-Bonacossi

still life in 1933, now in the Saint Louis Art Museum (inv. 114:1942), that he claimed was "essentially modern."[127] This is because it *was*—being a recent pastiche. Indeed, other twentieth-century pastiches trade on contemporary critical expectations associated with the Spanish school outlined above. A *Still Life with Basket of Apples and Roses, and Three Vessels*, attributed to the circle of Zurbarán in Sterling's European still life show of 1952, would appear to be one of these, though it, like others, betrays itself by the presentation of isolated and sharply defined elements in strong chiaroscuro.[128] Pictures of single still-life motifs that have been excised from larger compositions are also a consequence of these preconceptions.[129]

A corrective to the ahistorical fixation of critics on the themes outlined above appeared with Angulo Íñiguez and Pérez Sánchez's exhaustively documented biography and catalogue raisonné of Sánchez Cotán in 1972.[130] The authors place the artist in the concrete context of the artistic currents of his own time and place, though they also cite—and therefore give credence to—the mystical and metaphysical readings seemingly embedded in his historiography. Pérez Sánchez returned to the artist in his exhibition on Spanish still life in Madrid in 1983.[131] The other landmarks in the modern academic study of the artist's still lifes are by William B. Jordan in the catalogues of his exhibition on Spanish still life in 1985 at the Kimbell Art Museum and his memorable show at the Museo Nacional del Prado in 1992, in which all of Sánchez Cotán's known still lifes were brought together.[132]

In the exhibitions in which Sánchez Cotán's still lifes have been present—including *Spanish Still Life from Velázquez to Goya* at the National Gallery, London, in 1995—they have stolen the show for the general public (as evidenced in the newspaper reviews). While his still lifes appeal to people who will never have visited Spain or have known very much about the history of the country, his religious paintings are all but forgotten today. His series of historical works for the Charterhouse of Granada, which were so celebrated in the seventeenth century, attracts only scholarly and local interest. Indeed, the exhibition of *Still Life with Quince, Cabbage, Melon, and Cucumber* at the Meadows Museum as a "masterpiece in residence" demonstrates the ultimate irrelevance of the old hierarchy of genres of painting, which would have been so familiar to the artist and relegated his still lifes to a "lower" category of art. It is telling that Sánchez Cotán's still lifes are a particular source of inspiration to visual artists today. More ahistorical in their approach and much less constrained by the drive to rationalize and to explain that inheres in the discipline of the history of art, artists have long been sensitive to the pictures' visual allure and their strangeness. The artist's statement accompanying Cauleen Smith's video installation in response to *Still Life with Quince, Cabbage, Melon, and Cucumber*, exhibited at the San Diego Museum of Art in 2020, draws attention to precisely those mesmerizing visual qualities with which this essay began.[133] The painting's exhibition at the Meadows Museum has doubtless reached new audiences who will be intrigued and enthralled by the artist in ways in which he could not have begun to imagine.

Author's Acknowledgements

The author wishes to thank the late Mark A. Roglán, as well as Amanda W. Dotseth, the Linda P. and William A. Custard Director of the Meadows Museum, for the invitation to write on Sánchez Cotán and for their enthusiasm and expertise in bringing this project to fruition. For their conversations with the author on the treated herein, a debt of gratitude is owed to the director and to Elena Alcalá, María Cruz de Carlos Varona, Jaime García Máiquez, José Ramón Marcaida, Juan Pimentel Igea, and José Riello. For their help with locating sources and images, thanks are due to Michael A. Brown, Enrique Gutiérrez de Calderón, Rebecca Long, Fernando Marías, Almudena Pérez de Tudela, José Antonio de Urbina, and Joan Yeguas; and to the librarians at El Escorial, P. José Luis del Valle and Paz Fernández Rodríguez, and at the Museo Nacional del Prado, Celia Abril Berruezo and Jesús Alcocer Magro. The author is grateful to Anne Keefe, Danielle Naylor, and Miranda Saylor for invaluable editorial assistance.

Endnotes

1 Pliny the Elder, *Natural History*, trans. H. Rackham (London: William Heinemann, 1984), book 35, pp. 309–11. On the story and its relevance for mimesis (and the still life), see Sarah Blake McHam, *Pliny and the Artistic Culture of the Italian Renaissance: The Legacy of the* Natural History (New Haven: Yale University Press, 2013), pp. 47, 156, 226, 242, 281; William B. Jordan, *La imitación de la naturaleza: Los bodegones de Sánchez Cotán* (Madrid: Ministerio de Cultura, Museo del Prado, 1992), p. 22; S. Ebert-Schifferer, *Deceptions and Illusions: Five Centuries of Trompe l'Oeil Painting* (Washington: National Gallery of Art; London: Lund Humphries, 2002), pp. 109–21.

2 Jordan, *La imitación de la naturaleza*, p. 42, "otro lienzo de frutas adonde esta un canastico con ubas y es de diego de baldibieso."

3 For artistic responses to this story, see Ebert-Schifferer, *Deceptions and Illusions*, pp. 123–35.

4 On the "classical" origins of still life, see E.H. Gombrich, "Tradition and Expression in Western Still Life" in *Meditations on a Hobby Horse and Other Essays on the Theory of Art* (London: Phaidon Press, 1978), pp. 95–105; William B. Jordan, *Spanish Still Life in the Golden Age: 1600–1650* (Fort Worth: Kimbell Art Museum, 1985), p. 5; William B. Jordan and Peter Cherry, *Spanish Still Life from Velázquez to Goya* (London: National Gallery Publications, 1995), pp. 14–15. On illusionistic conventions of representation over time, see Ebert-Schifferer, *Deceptions and Illusions*, pp. 17–33.

5 Jordan calls it a "stage on which the high drama of art imitating nature could be played out." See *Spanish Still Life in the Golden Age*, p. 50.

6 The original canvas has been trimmed at the bottom and left edges, and to a greater extent on the right side (with some 3 centimeters missing here), while the top edge has been extended (by some 2 centimeters). For its present condition, see Jordan, *Spanish Still Life in the Golden Age*, p. 60; and the museum catalogue entry by John Marciari, *Italian, Spanish and French Paintings before 1850 in the San Diego Museum of Art* (San Diego: San Diego Museum of Art, 2015). The author is grateful to Jaime García-Máiquez for his assistance in producing this image.

7 His inventory lists a primed canvas with a window frame, called a *ventana* ("un lienzo emprimado para una ventana"), yet to have elements inserted into it, as noted by Jordan, *Spanish Still Life in the Golden Age*, p. 48. For X-radiographs, see Jordan, *La imitación de la naturaleza*, pp. 60, 64, 72; Rafael Romero Asenjo, *El bodegón español en el siglo XVII: Desvelando su naturaleza oculta* (Madrid: Icono I & R, 2009), p. 30.

8 Martin Soria emphasized the illusionistic aspect of the picture, calling it a trompe l'oeil. See Martin Soria, "Sánchez Cotán's *Quince, Cabbage, Melon and Cucumber*," *Art Quarterly* 8 (1945): p. 227.

9 Francisco Pacheco says painters "entretienen y muestran ingenio en la disposición y en la viveza" in pictures of dead animals—fish, fowl, and game—and *bodegones*. See Pacheco, *Arte de la pintura*, ed. Bonaventura Bassegoda

i Hugas (Madrid: Cátedra, 1990), p. 517. In a memorable phrase, Jordan describes Sánchez Cotán's still lifes as "ingeniosidades," or "paradigms of cleverness and skill, testaments of the power and performance of art in a mortal world" (*Spanish Still Life in the Golden Age*, p. 17). See also Jordan and Cherry, *Spanish Still Life from Velázquez to Goya*, pp. 18, 29.

10 Soria, "Sánchez Cotán's *Quince, Cabbage, Melon and Cucumber*," p. 226, noted the painting in his inventory.

11 The first analysis of the still lifes in the inventory in connection with existing pictures is in Jordan, *Spanish Still Life in the Golden Age*, pp. 47–50, followed by Jordan, *La imitación de la naturaleza*, pp. 41–46. On terminology, see Alfonso E. Pérez Sánchez, *Pintura española de bodegones y floreros de 1600 a Goya* (Madrid: Ministerio de Cultura, Dirección de Bellas Artes y Archivos, 1983), pp. 18–19; Jordan, *Spanish Still Life in the Golden Age*, pp. 16–17.

12 Jordan, *La imitación de la naturaleza*, p. 41.

13 Jordan, *La imitación de la naturaleza*, pp. 41, 66–69, cat. no. 3, "otro [lienzo] con un cardo y un francolin."

14 José Gudiol Ricart, "Natures mortes de Sánchez Cotán (1561–1627)," *Pantheon* 35 (1977): pp. 311–18; Jordan, *Spanish Still Life in the Golden Age*, p. 47, cat. no. 4, fig. I.11; Jordan, *La imitación de la naturaleza*, pp. 41, 52, "Yten un lienzo de frutas adonde esta una taza de castañas y unos ajos y zebollas." Its reappearance will clarify its status as an original or a copy. It represents a "new" cardoon, varies the motif of the hanging apples from the painting in the Prado (see fig. 4), and recycles the pair of hanging lemons from *Still Life with Fruit and Vegetables* (see fig. 5).

15 Jordan, *Spanish Still Life in the Golden Age*, pp. 48, 50, fig. I.12; Jordan, *La imitación de la naturaleza*, pp. 42–43, "un lienzo de un zenacho de zerezas y cestilla de albarcoques [*sic*]"; Romero Asenjo, *El bodegón español en el siglo XVII*, pp. 33–36.

16 Gudiol Ricart, "Natures mortes de Sánchez Cotán," p. 316, first noticed that this was the picture mentioned in the artist's inventory.

17 Diego Angulo Íñiguez and Alfonso E. Pérez Sánchez, *Historia de la pintura española: Escuela toledana de la primera mitad del siglo XVII* (Madrid: Instituto Diego Velázquez, 1972), p. 98, cat. no. 210; Pérez Sánchez, *Pintura española de bodegones*, p. 32, cat. no. 4; Jordan, *Spanish Still Life in*

the Golden Age, p. 56, cat. no. 2; Jordan, *La imitación de la naturaleza*, p. 74–77, cat. no. 5.

18 Jordan, *Spanish Still Life in the Golden Age*, pp. 48–50, 51, fig. I.13; Jordan, *La imitación de la naturaleza*, pp. 43–45; Peter Cherry, John Loughman, and Lesley Stevens, *In the Presence of Things: Four Centuries of European Still-Life Painting* (Lisbon: Calouste Gulbenkian Museum, 2010), pp. 136–37, cat. no. 2.

19 Angulo Íñiguez and Pérez Sánchez, *Historia de la pintura española*, pp. 60–61, 97, cat. no. 205; Diego Angulo Íñiguez and Alfonso Pérez Sánchez, *La pintura madrileña del segundo tercio del siglo XVIII: Pereda, Leonardo, Rizi* (Madrid: Consejo Superior de Investigaciones Científicas, 1983), p. 33, cat. no. 5; Jordan, *Spanish Still Life in the Golden Age*, p. 63, cat. no. 5; Jordan, *La imitación de la naturaleza*, pp. 8–81, cat. no. 6; Jordan and Cherry, *Spanish Still Life from Velázquez to Goya*, pp. 32–34.

20 Jordan, *Spanish Still Life in the Golden Age*, p. 17.

21 Angulo Íñiguez and Pérez Sánchez, *Historia de la pintura española*, p. 41, identified Valdivieso with the Toledan silversmith of this name. Emilio Orozco Díaz, *El pintor Fray Juan Sánchez Cotán* (Granada: Universidad de Granada, 1993), p. 78, noted Valdivieso's profession of *cordonero* in the original document (which had not been transcribed in Julio Cavestany, *Floreros y bodegones en la pintura española* (Madrid: Palacio de la Biblioteca Nacional, 1940), but opted for his identification with the silversmith on the basis of the large quantities of money he owed Sánchez Cotán. Carmen Ripollés defends the identification on grounds of cognate artistic interests between him and Sánchez Cotán. The argument that there were two Valdiviesos based on variations in the spelling of the surname in the estate documents is not plausible. See Ripollés, "Juan Sánchez Cotán's Still Lifes and Artistic *Ingenio* in Early Modern Toledo," *Boletín del Museo del Prado* 34, no. 54 (2018): p. 108, n. 40. For "cordón," see *Diccionario de Autoridades 1792*: "Cierto género de cordel redondo, que se hace de seda, lino o lana, unas veces retorcida, y otras texida, y sirve para abrochar los jubones y otras cosas, y para guarnecer y cairelar diferentes obras." The *cordonería* remains an important business for the paraphernalia involved in Holy Week in Spain. For the world of tassels, fringes, and braid in the past—albeit in Britain—see Annabel Westman, *Fringe, Frog and Tassel: The Art of the Trimmings Maker in Interior Decoration* (London: Philip Wilson, 2019).

22 For Sánchez Cotán's process of copying, see Pérez Sánchez, *Pintura española de bodegones*, p. 31; Jordan, *Spanish Still Life in the Golden Age*, pp. 47, 50, 54, 61.

23 See William B. Jordan, *Juan van der Hamen y León and the Court of Madrid* (New Haven: Yale University Press, 2005), pp. 75–119, for Van der Hamen's practice in the early 1620s. See also Romero Asenjo, *El bodegón español en el siglo XVII*, p. 90; Cherry, Loughman, and Stevens, *In the Presence of Things*, pp. 22–25, 49–53.

24 Florike Egmond, *Eye for Detail: Images of Plants and Animals in Art and Science, 1500–1630* (London: Reaktion Books, 2017), pp. 94–95.

25 Jordan, *Spanish Still Life in the Golden Age*, p. 50, makes the point that repeated images carry the same degree of conviction as the first. On the idea of the image made *ad vivum*, see Claudia Swan, "*Ad vivum, naer het leven*, from the Life: Defining a Mode of Representation," *Word and Image* 11, no. 4 (1995): pp. 352–72; Thomas Balfe, Joanna Woodall, and Claus Zittel, eds. *Ad vivum? Visual Materials and the Vocabulary of Life-Likeness in Europe Before 1800* (Leiden: Brill, 2019). On the idea of representations from observation being replicas of the first image, which is nature itself, and reproducible without any loss of authority as images *ad vivum*, see Sheila McTighe, *Representing from Life in 17th-Century Italy* (Amsterdam: Amsterdam University Press, 2020), pp. 31, 53–54.

26 The provisional findings offered here were made with the inestimable help of Jaime García-Máiquez. These are dependent on the very limited range of technical documentation currently available for the still lifes of Sánchez Cotán in the collections of the San Diego Museum of Art and the Chicago Art Institute.

27 See Jordan, *Spanish Still Life*, pp. 50, 61, on the dangers of a putative chronology of the still lifes which places the fuller compositions before the more austere ones and based on so little objective information.

28 Oiled paper, which is mentioned in the artist's inventory ("un papel arrollado anazeytado" and "unos papeles enazeitados de pintura"), would have provided a means of copying elements from one picture to another. See Zahira Véliz Bomford, "Velázquez Composes: Prototypes, Replicas, and Transformations," *Colnaghi Studies Journal* 3 (2018): pp. 93–111, especially pp. 97–100 on analogous methodologies of reproduction of the individual still-life motifs in Velázquez's kitchen scenes and (p. 95) for a useful definition of terms.

29 Angulo Íñiguez and Pérez Sánchez remarked that if it were not signed, the picture would pass as a work by Sánchez Cotán. See their *Historia de la pintura española*, 108, cat. no. 2. See also Jordan, *Spanish Still Life in the Golden Age*, 47; Jordan, *La imitación de la naturaleza*, 82–84, cat. no. 7.

30 Peter Cherry, "El *Bodegón de caza, hortalizas y frutas* de Juan Sánchez Cotán," in *Los tesoros ocultos del Museo del Prado*, ed. Francisco Calvo Serraller et al., (Madrid Fundación Amigos Museo del Prado and Barcelona Círculo de Lectores, 2017), pp. 199–222.

31 Pacheco, *Arte de la pintura*, p. 517. On Sánchez Cotán's painting technique, see Romero Asenjo, *El bodegón español en el siglo XVII*, pp. 25–33.

32 See McTighe, *Representing from Life*, pp. 24, 28–30. See Egmond, *Eye for Detail*, pp. 88–125 on "persuasive high definition" as a visual mode.

33 See Peter Cherry, *Arte y naturaleza: El bodegón español en el Siglo de Oro* (Madrid: Fundación de Apoyo a la Historia del Arte Hispánico, 1999), p. 58, for "otro lienço de frutas contraechas del natural," inventoried in 1613 at the Burgos estate of Juan Fernández de Velasco, Condestable de Castilla. See also María Cruz de Carlos Varona, "'The Authority of Sacred Paintbrushes': Representing Medieval Sainthood in the Early Modern Period," in *Sacred Spain: Art and Belief in the Spanish World*, ed. Ronda Kasl (Indianapolis: Indianapolis Museum of Art, 2010), pp. 255–57. Covarrubias's Spanish dictionary of 1611 defines *contrahecho* in terms of imitation and the verb *contrahazer* as "imitar alguna cosa, de lo natural, o artificial." On the term *contrafactum* in northern Europe, see Peter Parshall, "*Imago Contrafacta*: Images and Facts in the Northern Renaissance," *Art History* 16, no. 4 (1993): pp. 554–79. See also Svetlana S. Alpers, *The Art of Describing: Dutch Art in the Seventeenth Century* (London: John Murray, 1983), pp. xx–xxi on the "descriptive mode" of painting.

34 *Still Life with Game, Vegetables, and Fruit* (fig. 4); *Still Life with Cardoon, Apples, and Garlic* (note 14); *Still Life with Cardoon and Carrots* (fig. 7).

35 Parshall, "Imago Contrafacta." For the scientific dimension of still-life painting, see Jordan and Cherry, *Spanish Still Life from Velázquez to Goya*, pp. 18–19; José Ramón Marcaida and Juan Pimentel, "Dead Natures or Still Lifes? Science, Art, and Collecting in the Spanish Baroque," in *Collecting Across Cultures: Material Exchanges in the Early Modern Atlantic World*, ed. Daniela Bleichmar and Peter Mancall (Philadelphia: University of Pennsylvania Press, 2013), pp. 105–6. See also Juan Pimentel and José Ramón

Marcaida, "La ciencia moderna en la cultura del Barroco," *Revista de Occidente* 328 (2008): pp. 146–50.

36 Zrika Zaremba Filipczak, *Picturing Art in Antwerp, 1550–1700* (Princeton: Princeton University Press, 1987).

37 Cherry, *Arte y naturaleza*, p. 58; Carlos Varona, "The Authority of Sacred Paintbrushes," pp. 255–57, for "dos quadros al olio de ffruta [*sic*] pintados sobre tabla" in the "biblioteca" of his houses in Madrid in 1608.

38 Sarah Schroth, "Early Collectors of Still-Life Painting in Castile," in Jordan, *Spanish Still Life in the Golden Age*, pp. 29–30; Jordan, *Spanish Still Life in the Golden Age*, pp. 45–46; Jordan and Cherry, *Spanish Still Life from Velázquez to Goya*, pp. 24–25; Cherry, *Arte y naturaleza*, p. 96. The picture is listed in the inventory of García de Loaysa in Madrid as "otro quadro en q[ue] [h]ay fruta pintada, de melon, menbrillo granada naranja çanaoria y cardo."

39 For those in Philip II's quarters in El Escorial, see Fernando Checa Cremades, *Felipe II: Mecenas de las artes*, 2nd ed. (Donostia: Nerea, 1992), pp. 245–50.

40 On this problem in natural history, see Brian W. Ogilvie, *The Science of Describing: Natural History in Renaissance Europe* (Chicago: University of Chicago Press, 2006); Eileen Reeves, "The New Sciences and the Visual Arts," in *A Companion to Renaissance and Baroque Art*, ed. Babette Bohn and James M. Saslow (Hoboken: John Wiley and Sons, 2013), pp. 322–25. See Janice Neri, *The Insect and the Image: Visualizing Nature in Early Modern Europe, 1500–1700* (Minneapolis: University of Minnesota Press, 2011), pp. xviii–xix, on the assertion of the authority of the scientist over the artisan in this respect.

41 A talented follower of Sánchez Cotán, known to art history as the Stirling-Maxwell Master, included the cardoon flower emerging from behind the window frame in a number of his paintings. See Jordan and Cherry, *Spanish Still Life from Velázquez to Goya*, pp. 32, 34, fig. 19; *Incólume: Bodegones del Siglo de Oro* (Barcelona: MNAC, 2015), pp. 42–45.

42 Pamela H. Smith, "Art, Science, and Visual Culture in Early Modern Europe," *Isis* 97, no. 1 (2006): pp. 83–100.

43 In artistic treatises of the period, the universalizing function of drawing was described as the imitation of nature and everything to be found in the natural world. See Gaspar Gutiérrez de los Ríos, *Noticia general para la estimación de las artes, 1600* (Madrid: Fundación de Apoyo a la Historia del Arte Hispánico, 2006), pp. 157–59; see also Francisco Calvo Serraller, *La teoría de la pintura en el Siglo de Oro*, (Madrid: Cátedra, 1981), 166.

44 Peter Cherry, "Objects and Objectives in the Courtly Still-Life Paintings of Juan van der Hamen," in *La monarquia de Felipe III: La Casa del Rey*, ed. José Martinez Millan (Madrid: Instituto Universitario, 2017), pp. 2791–2870. See p. 2869 for "una mançana de madera" in the *camarín* of the Duchess of Béjar in Madrid in 1602.

45 Real Biblioteca del Monasterio de San Lorenzo de El Escorial, 28.II.3. See Gregorio de Andrés, "Catálogo de las colecciones de dibujos de la Real Biblioteca de El Escorial," *Archivo Español de Arte*, 161 (1968): pp. 3–19, cat. no. 6. The album is in an eighteenth-century binding, measuring 407 × 283 mm, with the pages trimmed. The sequential numbering of the pages comes from the time of the drawings. Only two images—of birds—are captioned (fols. 2, 18). Another album is cited without commentary in José Miguel Morán Turina and Fernando Checa, *Las casas del rey. Casas de campo, cazaderos y jardines, siglos XVI y XVII* (Madrid: Ediciones El Viso, 1986), p. 38. These albums contradict Egmond, *Eye for Detail*, p. 16, who claims that no sixteenth-century drawings of flora and fauna of Spain and Portugal are known to exist.

46 Jordan, *La imitación de la naturaleza*, p. 62. Another still life in Sánchez Cotán's studio known in copies represents baskets of cherries and apricots and what looks like white sorghum, a grain with African origins, dynamically rising up behind the window frame at the left and into the space in front of it. Jordan, *La imitación de la naturaleza*, p. 43.

47 See Neri, *The Insect and the Image*, p. xix, on the process of collecting, describing, and displaying the natural world as a social activity.

48 See Pérez Sánchez, *Pintura española de bodegones*, pp. 21–28; Jordan, *Spanish Still Life in the Golden Age*, pp. 1–17; Jordan and Cherry, *Spanish Still Life from Velázquez to Goya*, pp. 13–17, for accounts of the origins of still life in Spain. For the artist's career in Toledo, see Angulo Íñiguez and Pérez Sánchez, *Historia de la pintura española*, pp. 39–67, 68–102, and 58–63 on his still lifes; Jordan, *Spanish Still Life in the Golden Age*, pp. 40–41; Jordan and Cherry, *Spanish Still Life from Velázquez to Goya*, pp. 28–29.

49 Pacheco, *Arte de la pintura*, p. 511. Juan Miguel Serrera, "El viaje a Marruecos de Blas de Prado: Constatación documental," *Boletín del Museo e Instituto Camón Aznar* 25 (1986): pp. 23–26, showed that the trip was commissioned

by the VII Duque de Medina Sidonia. For the convincing argument that Prado served the *jerife* Ahmad al-Mansur in Fez in his capacity of portraitist, see María Teresa Cruz Yábar, "El final madrileño de Blas de Prado," *Anales del Instituto de Estudios Madrileños* 54 (2014): pp. 33–87; Cruz Yábar, "El viaje de Blas de Prado a Berbería en 1593 y el regreso del pintor," in *El Greco en su IV Centenario: Patrimonio hispánico y diálogo intercultural*, ed. Esther Almarcha, Palma Martínez-Burgos, and Elena Sainz (Cuenca: Ediciones de la Universidad de Castilla-La Mancha, 2016): pp. 1117–34. See Jordan, *Spanish Still Life in the Golden Age*, pp. 7–16; Jordan and Cherry, *Spanish Still Life from Velázquez to Goya*, pp. 17–18, on Pacheco's account of still life.

50 He says "no se pueden dar reglas a esta pintura, más de que se use de finos colores y de puntual imitación." Pacheco, *Arte de la pintura*, p. 517.

51 Norman Bryson, *Looking at the Overlooked: Four Essays on Still Life Painting* (Cambridge, MA: Harvard University Press, 1990).

52 Pacheco, *Arte de la pintura*, p. 511. Pacheco characterized him as a naturalistic artist, saying that he made "obras famosas" in the Cartuja (Charterhouse) "con la imitación de lo natural." Pacheco, *Arte de la pintura*, p. 220.

53 The inventory entry ("un lienzo imprimado del d[ic]ho Ju[an] ss[anch]ez q[ue] es retrato") shows that the picture was primed and refers to the artist's name as the subject of the portrait. See Angulo Íñiguez and Pérez Sánchez, *Historia de la pintura española*, pp. 43, 85, no. 124, for his self-portrait in the *Virgin of the Rosary*.

54 Cruz Yábar, "El viaje de Blas de Prado a Berbería," pp. 126–27, sees paintings by Prado in the inventory of the Madrid silversmith Gaspar de Ledesma in 1618, an associate of his: two small portraits of sultanas (Moroccan princesses), a painting of two plates of fruit, and a painting of two vases of flowers. See Pérez Sánchez, *Pintura española de bodegones*, p. 30, nos. 1–2; Jordan, *Spanish Still Life in the Golden Age*, pp. 10–11, for two pictures of tazzas of fruit attributed to Prado.

55 Francisco Gómez de Sandoval y Rojas, duke of Lerma (1552–1625), was foremost among the early collectors of still life. In 1603, an inventory of his collection listed two works of this kind: "un lienço de frutas" and "una tablilla de un plato de frutas." Sarah Schroth, *The Private Picture Collection of the Duke of Lerma* (New York: New York University Press, 1990), pp. 171, inv. 1, no. 248; p. 188, inv. 1, no. 467. For a surprising and delightful addition to the prehistory of the genre—sixty-eight plates of food carved around the door jamb of the entrance to the sacristy of Seville Cathedral in 1533–35, including a plate of grapes with a bird flying down to eat them—see Juan Clemente Rodríguez Estévez, *El universal convite: Arte y alimentación en la Sevilla del Renacimiento* (Madrid: Ediciones Cátedra, 2021). For early collectors of still lifes in Spain, see Sarah Schroth, "Early Collectors of Still-Life Painting in Castile" in Jordan, *Spanish Still Life in the Golden Age*, pp. 34–35; Jordan and Cherry, *Spanish Still Life from Velázquez to Goya*, p. 25; Cherry, *Arte y naturaleza*, pp. 55–61; Sarah Schroth in *El Greco to Velázquez: Art During the Reign of Philip III*, ed. Sarah Schroth and Ronni Baer (Boston: MFA Publications, 2008), pp. 267–68.

56 For Prado, see Amelia López-Yarto Elizalde and Isabel Mateo Gómez, *Pintura toledana de la segunda mitad del siglo XVI* (Madrid: Consejo Superior de Investigaciones Científicas, 2003), pp. 246–69; Palma Martínez-Burgos García, "El Greco y Preboste: De pintores y artesanos," in *El Greco en su IV Centenario: Patrimonio hispánico y diálogo intercultural*, ed. Esther Almarcha, Palma Martinez-Burgos, and Elena Sainz (Cuenca: Ediciones de la Universidad de Castilla-La Mancha, 2016), pp. 123–38.

57 López-Yarto Elizalde and Mateo Gómez, *Pintura toledana*, pp. 253–57, p. 255, fig. 223 from the convent of San Benito in Zafra (Badajoz).

58 David Ekserdijan, *Still Life before Still Life* (New Haven: Yale University Press, 2018); Cavestany, *Floreros y bodegones*, pp. 26–27; Pérez Sánchez, *Pintura española de bodegones*, p. 22. See, for example, two fruit and flower still-life arrangements in the altarpiece of the Virgin and Child with Saint John the Baptist by an unidentified artist in a side altar erected after 1583 in the church of the Hieronymite convent of San Pablo in Toledo. López-Yarto Elizalde and Mateo Gómez, *Pintura toledana*, pp. 258–59, attribute it to Blas de Prado. See also Balbina Martínez Caviró, *Conventos de Toledo: Toledo, Castillo Interior* (Madrid: Ediciones el Viso, 1990), pp. 292–93, 301–2.

59 Cruz Yábar, "El final madrileño de Blas de Prado," p. 39.

60 For his few books, see Jordan and Cherry, *Spanish Still Life*, p. 188, n. 10.

61 Cruz Yábar, "El final madrileño de Blas de Prado," pp. 54–55, 76–80, doc. 12. Cruz Yábar, p. 55, suggests that Sánchez Cotán's inventory may include some of Prado's own paintings.

62 Pacheco, *Arte de la pintura*, pp. 460–61; Jordan, *Spanish Still Life in the Golden Age*, pp. 11, 13–14.

63 For these pictures in the collection of the third duke of Alcalá, see Jonathan Brown and Richard L. Kagan, "The Duke of Alcalá: His Collection and Its Evolution," *Art Bulletin* 69, no. 2 (1987): p. 238. In the valuation of the collection in 1641, these were referred to as nine "canastos de frutas." David Mallén Herráiz, "Francisco de Zurbarán y Francisco de Herrera el Viejo, tasadores de la colección pictórica del III duque de Alcalá," *Goya* 372 (2020): p. 221, n. 46.

64 See Julio Cavestany, *Floreros y bodegones*, pp. 22–24, for this tradition of wall painting in Spain.

65 See Giulia Caneva, *Il mondo di Cerere nalla Loggia di Psiche: Villa La Farnesina, sede dell'Accademia nazionale dei Lincei* (Rome: Palombi, 1992); Antonio Sgamellotti and Giulia Caneva, *I colori della prosperità: Frutti del Vecchio e Nuovo Mondo* (Rome: Bardi Edizioni), 2017.

66 See Carmen Ripollés, "Naturaleza, cienca e imperio: Los cuartos de las frutas en la Alhambra y los orígenes del bodegón en España," *Reales Sitios* 204 (2015): pp. 24–37, especially p. 34, for the relationship between the decoration and the gardens seen from these rooms. See also Nuria Martínez Jiménez, *Pintura mural del Renacimiento en la Alhambra* (Granada: Patronato de la Alhambra y Generalife, 2021); Alexandre Mayner, "Pintor de mitos y paisajes," *Goya* 378 (2022): 3–15.

67 Cavestany, *Floreros y bodegones*, pp. 22, 65. Ingvar Bergström emphasized the importance of this cycle for the "prehistory" of still life in Spain and for Sánchez Cotán. The paintings of Medina (and his collaborators) were valued by Juan de Borgoña, who painted the frescoes of the chapter room in 1509–11 and may well have designed the cycle of the anteroom. The work was paid for in February 1511. See Ingvar Bergström, *Maestros españoles de bodegones y floreros del siglo XVII* (Madrid: Insula, 1970), pp. 13–16, 19, 22, 48.

68 Juan Luis Blanco Mozo, "Juan de Borgoña y las pinturas de la Sala Capitular de la Catedral de Toledo" in *Restauración de la Sala Capitular de la Catedral de Toledo* (Madrid: Fundación ACS, 2020), p. 33.

69 Blanco Mozo, "Juan de Borgoña," pp. 35–36. This decoration responded in particular to the frescoes painted during the papacy of Nicholas V (1447–55) in the Bibliotheca Graeca of the Vatican, attributed to Andrea Castagno, and to those by Davide and Domenico Ghirlandaio in the Sala Latina of the library painted during the papacy of Sixtus IV (1471–84). See also Bergström, *Maestros españoles*, p. 16. For ancient precedents described by Pliny and their revival in Rome, see McHam, *Pliny and the Artistic Culture*, pp. 171–73.

70 Blanco Mozo, "Juan de Borgoña," pp. 83–84.

71 Cloe Cavero de Carondelet, *Una villa toledana del Quinientos: El cigarral del cardenal Quiroga* (Madrid: Auditores de Energia y Medio Ambiente, 2014).

72 Angulo Íñiguez and Pérez Sánchez, *Historia de la pintura española*, pp. 49–50; Alfonso E. Pérez Sánchez, *Pintura barroca en España (1600–1750)* (Madrid: Cátedra, 1992), p. 125.

73 See Pérez Sánchez, *Pintura española de bodegones*, p. 15; Jordan and Cherry, *Spanish Still Life from Velázquez to Goya*, pp. 19–20; Cherry, Loughman, and Stevens, *In the Presence of Things*, p. 26.

74 Bryson, *Looking at the Overlooked*, 66. Mindy Nancarrow Taggard interpreted them as admonitions against the sin of gluttony. See "Juan Sánchez Cotán and the Depiction of Food in Seventeenth-Century Spanish Still-Life Painting," *Pantheon* 48 (1990): pp. 76–80.

75 Angulo Íñiguez and Pérez Sánchez, *Historia de la pintura española*; Orozco Díaz, *El pintor Fray Juan Sánchez Cotán*, pp. 93–94, 358–60, cat. no. 79.

76 Antonio Palomino y Velasco mentions the artist's manual work at the Granada Charterhouse. See *El museo pictórico y escala óptica. El Parnaso español pintoresco laureado*, Vol. III, (Madrid: Aguilar, 1988), p. 107. See also Jordan, *Spanish Still Life in the Golden Age*, pp. 43; 52, n. 1. For the fullest discussion of the role of lay brothers, see María Cruz de Carlos Varona, "Historias e iconos: Fray Juán Sánchez Cotán y la cultura martirial de la Europa moderna," *Tiempos Modernos* 7, no. 20 (2010–11): pp. 1–50.

77 Pérez Sánchez, *Pintura española de bodegones*, p. 33, calls *Still Life with Cardoon and Carrots* a "Lenten still life" ("bodegón de cuaresma"). See also Don Denny, "Sánchez Cotán, *Still Life with Carrots and a Cardoon*," *Pantheon* 30 (1972): 48–53, for the supposed "disguised" symbolism in the picture, in which the cardoon represents the flail of Christ's flagellation and the three carrots and parsnip the four nails of His Crucifixion. It has not achieved consensus among scholars.

78 For other readings of religious sentiment of his still lifes, see Bodo Vischer, "'La transformación en Dios': Zu den Stilleben von Juan Sánchez Cotán, 1560–1627," in *Zeitschrift für Ästhetik und allgemeine Kunstwissenschaft* 38 (1993): pp. 269–308; Cyril Gerbron, "Présences énigmatiques: Les natures mortes de Juan Sánchez Cotán," *Artibus et Historiae* 38, no. 75 (2017), pp. 165–180. See François Quiviger, "Signifier le vide: La nature morte au melon de Juan Sanchez Cotán," *Literatures Classiques* 56 (2005): pp. 177–85, for the still lifes in the context of meditative practices.

79 Jordan, *Spanish Still Life in the Golden Age*, p. 50.

80 See also Angulo Íñiguez and Pérez Sánchez, *Historia de la pintura española*, p. 60; Pérez Sánchez, *Pintura española de bodegones*, p. 28; Jordan, *Spanish Still Life in the Golden Age*, p. 51; Jordan and Cherry, *Spanish Still Life from Velázquez to Goya*, p. 21; Peter Cherry, "The Hungry Eye: The Still Lifes of Juan Sánchez Cotán," *Konsthistorisk tidskrift/Journal of Art History* 65, no. 2 (1996): p. 80.

81 See Gutiérrez de los Ríos, *Noticia general para la estimación de las artes*, pp. 196 ff., libro IV, on why the cultivation of the land should be considered a liberal art, based on farmers' understanding of nature. This idea would surely have boosted the artistic status and authority of a still-life painter such as Juan Fernández "El Labrador," who, it was believed, painted the fruits of the land he cultivated.

82 Jordan, *La imitación de la naturaleza*, 33–35; Cherry, Loughman, and Stevens, *In the Presence of Things*, pp. 29–31. A large still life (114 × 121 cm) by the same artist—"baptized" as the Master of the Months—has recently been discovered (Galería Caylus, Madrid), whose excellent condition allows a full appreciation of its author's ambition in representing an extensive catalogue of fruits and vegetables, arranged on a tabletop and hanging from a beam. The pictorial decoration of the Huerta de la Ribera, which the duke of Lerma sold to King Philip III in 1607, included a set of six paintings of "Pintados en ellos ffructas [sic], Carnes, y otras cosas significadas en cada uno de ellos un mes del año," which the duke apparently owned since at least 1603. Schroth, "Early Collectors of Still-Life Painting in Castile," 35; Jordan, *La imitación de la naturaleza*, 33–34.

83 See Jordan, *Spanish Still Life in the Golden Age*, 49, fig. I.11.

84 See Jordan, *Spanish Still Life in the Golden Age*, 50, fig. I.12.

85 See Jordan, *Spanish Still Life in the Golden Age*, 51, fig. I.13.

86 See François Quiviger, *The Sensory World of the Renaissance* (London: Reaktion, 2010), pp. 167–68. The author was unable to read for this essay Mindy Nancarrow, "Sight, Science, and the Still-Life Paintings of Juan Sánchez Cotán," in *Sense and the Senses in Early Modern Art and Cultural Practice*, ed. Alice E. Sanger and Sive Tove Kulbrandstad Walker (Farnham: Ashgate, 2012), pp. 63–74.

87 See Jordan, *Spanish Still Life in the Golden Age*, p. 61, cat. no. 4, for the critical history of the work.

88 Sheila McTighe, "Foods and the Body in Italian Genre Paintings, about 1580: Campi, Passarotti, Carracci," *Art Bulletin*, 86, no. 2 (2004): pp. 301–23. See also Massimo Montanari, *El hambre y la abundancia: Historia y cultura de la alimentación en Europa* (Barcelona: Crítica, 1993).

89 Mary D. Garrard opens up this possibility and calls still lifes "instruments of health support." See "The Not-So-Still Lifes of Giovanna Garzoni," in *The Immensity of the Universe in the Art of Giovanna Garzoni*, ed. Sheila Barker (Livorno: Sillabe, 2020). On seventeenth-century theories about the role of the imagination in precipitating or preventing the onset of disease, see Sheila Barker, "Poussin, Plague, and Early Modern Medicine," *Art Bulletin* 86, no. 4 (2004), pp. 660–62; Frances Gage, *Painting as Medicine in Early Modern Rome: Giulio Mancini and the Efficacy of Art* (University Park: Penn State University Press, 2016).

90 See Schroth, "Early Collectors of Still-Life Painting in Castile," pp. 30–31, 35–37, for the location of the pictures in an inventory of 1623. See William Jordan, "La Galería del Mediodía de El Pardo y los orígenes de la naturaleza muerta en Madrid," in *Los pintores de lo real* (Barcelona: Galaxia Gutenberg, 2008), for a synthesis of his extensive research on the Pardo series. The royal inventories say that these were *sobrepuertas*, even though there were only three doors and six windows in the gallery. For the remodelling and decoration of the Pardo after the fire of 1604, see Checa Cremades and Morán Turina, *Las casas del rey*, pp. 132–34, 152–55. For the painting of 1619 by Van der Hamen, see Peter Cherry, "La primera naturaleza muerta de Juan Van der Hamen," *Ars Magazine* 51 (2021): pp. 140–41.

91 Jordan, *La imitación de la naturaleza*, pp. 47–52; Jordan, "La Galería del Mediodía," pp. 129–33.

92 Jordan, *Juan van der Hamen y León*, pp. 54–55.

93 Archivo General de Palacio, Madrid, box 9404, no. 3; Jordan, *Juan van der Hamen y León*, p. 300, n. 22. See Jordan, "La Galería del Mediodía," p. 58, p. 130, n. 27 for a transcription of the relevant entries in this document. The sequence of inventory numbers of the six still lifes in this document are: 140, 142, 145, 149, 152 and 154. The pictures are recorded in situ and with the same numbering in inventories of El Pardo of 1674 and 1701–3. See also Cherry, "La primera naturaleza muerta de Juan Van der Hamen."

94 Jordan, "La Galería del Mediodía," p. 120, n. 27: "140 Un frutero Pequeño Con su marco de oro y negro con un cardo."

95 Jordan, "La Galería del Mediodía," p. 120, n. 27: "142 Un frutero Pequeño Con su marco de oro y negro con un cesto de albaricoques."

96 Jordan, "La Galería del Mediodía," p. 120, n. 27: "145 Un frutero Pequeño Con su marco dorado y negro y un Melon abierto en medio."

97 See the inventory number in the reproduction in Jordan, *Spanish Still Life in the Golden Age*, p. 62, plate 4; Jordan, *La imitación de la naturaleza*, p. 63.

98 Jordan, "La Galería del Mediodía," p. 120, n. 27: "152 Un frutero Pequeño Con su marco de oro Y negro Con Una zesta de higos y Ubas." In the royal inventory of El Pardo from 1701–3, this was said to represent a tray of figs and grapes: "139. Un fruttero pequeño con Un azafatte de Ygos y Ubas." See Jordan, *La imitación de la naturaleza*, p. 51.

99 Jordan, *La imitación de la naturaleza*, pp. 42, 52.

100 Jordan, "La Galería del Mediodía," p. 120, n. 27: "154. Un frutero Pequeño Con su marco de oro y negro Con dos Zebollas." See Jordan, *La imitación de la naturaleza,* p. 52.

101 They are listed in the inventory drawn up after the death of Charles II in 1700; see Gloria Fernández Bayton, *Inventarios reales: Testamentaría del rey Carlos II, 1701–1703* vol. 2 (Madrid: Museo del Prado, 1981), pp. 143–45; Jordan, *La imitación de la naturaleza*, p. 51. Revisions to this inventory made after the War of Succession show that these works had been moved to another room of the palace. See Fernández Bayton, *Inventarios* reales, 143–45, for these later annotations and the numbering of the works in the "Pieza 6ª," and ibid., pp. 11–13, for discussion.

102 Jordan suggests that the six still-life paintings from the Pardo are listed among the paintings from royal residences gathered at the Escorial in 1809 by Fréderic Quilliet, the artistic advisor to Joseph Bonaparte, for shipment to Madrid for a projected national museum. However, the published documentation is simply too vague to sustain this hypothesis. See Jordan, "La Galería del Mediodía," pp. 136–37.

103 The first scholar to explore this American provenance was Jordan, *Spanish Still Life in the Golden Age*, p. 58–60; Jordan, *La imitación de la naturaleza*, pp. 53–55.

104 See Jordan, *Juan van der Hamen*, p. 99; Jordan, "La Galería del Mediodía," pp. 131–32, 136–37.

105 See Morán Turina and Checa Cremades, *Las casas del rey*, p. 154. See, for instance, Becerra's frescoes in the Torre de la Reina of El Pardo painted in the 1560s, with lunettes of landscape paintings and with bird motifs between the windows, and the landscape lunettes and fruit swags in the decoration of the ceiling of the quarters of the infanta at El Pardo, painted by Luis and Francisco de Carvajal 1607–11. Magdalena de Lapuerta Montoya, *Los pintores de la corte de Felipe III: La Casa Real de El Pardo* (Madrid: Fundación Caja Madrid, 2002). See note above for still lifes of the months hanging at the duke of Lerma's Quinta de la Huerta.

106 This would apply to the motifs itemized in Van der Hamen's painting, made specifically for the Pardo. See Juan Gómez de Mora's commentaries and his plans of the royal houses made in 1626 in Lapuerta Montoya, *Los pintores de la corte*, p. 41, in which the architect says that in November and December, "benados, jabalies, lobos, çorras y mucha dibersidad de abes de rapiña, conejos y gamos" are hunted.

107 See Juan Gómez de Mora's plan of the *planta principal* of the Pardo illustrated in Francisco Íñiguez Almech, *Casas reales y jardines de Felipe II* (Madrid: Consejo Superior de Investigaciones Científicas, 1952), p. 111, p. 253, fig. 39.

108 Soria, "Sánchez Cotán's *Quince*," pp. 135–36, fig. 8. Soria repeated the main points of the article in George Kubler and Martin Soria, *Art and Architecture in Spain and Portugal and the American Dominion: 1500–1800* (New York: Penguin Books, 1959), pp. 221–22.

109 Soria, "Sánchez Cotán's *Quince*," p. 226.

110 August L. Mayer, "The Education of the Virgin by Zurbarán," *Burlington Magazine* 44, no. 256 (1924): p. 212, mentioned the picture and a black-and-white photograph of it was published in August L. Mayer, "A Still-Life by

Zurbarán," *Burlington Magazine* 49, no. 281 (1926): p. 55. See Roberto Longhi and August Liebmann Mayer, *Gli antichi pittori spagnoli della collezione Contini-Bonacossi* (Rome: Bestetti e Tumminelli, 1930), pp. 41–42, cat. no. 64, plate LXIV. See also Jordan, *Spanish Still Life in the Golden Age*, p. 22.

111 Martin S. Soria, *The Paintings of Zurbarán* (London: Phaidon, 1953), pp. 13–14; pp. 149–50, cat. no. 71, as a full page color plate. The idea derives from Longhi and Mayer, *Gli antichi pittori spagnoli*, pp. 41–42, for whom the composition is "like flowers on an altar, strung together like litanies to the Madonna." See also Cavestany, *Floreros y bodegones*, pp. 28–29.

112 Soria, *The Paintings of Zurbarán*, p. 24. For Zurbarán's aesthetic qualities, see Martin Soria, "Zurbarán: A Study of His Style," *Gazette des Beaux Arts* 25 (1944): pp. 32–48. For an overview of this artist in the United States, see Susan Grace Galassi, "Paintings Cut Loose: Zurbarán's Work in Museums in the United States, in *Zurbarán: Jacob and His Twelve Sons, Paintings from Auckland Castle*, ed. Susan Grace Galassi, Edward Payne, and Mark A. Roglán, (Madrid: Centro de Estudios Europa Hispánica, 2017). For the construction of Zurbarán as a simple man of "unsophisticated faith," see Alexandra Letvin, "'A Terrifying Object': The Invention of Zurbarán," in *Jacob and His Twelve Sons*, pp. 65–66.

113 María Luisa Caturla, *Zurbarán: Estudio y catálogo de la exposición celebrada en Granada en junio de 1953* (Madrid: Dirección de Bellas Artes, Ministerio de Educación Nacional, 1953). Emilio Orozco Díaz's introductory essay to this catalogue (pp. 15–17) compares the painting of Sánchez Cotán and Zurbarán in terms of their humble and ingenuous approach to nature, informed by an ascetic and essentially "Spanish" mystical spirituality. In "Cotán y la tradición artística toledana (Breve capítulo de un libro inédito)," *Studies in the History of Art* 13 (1984): 125–30, Emilio Orozco Díaz linked Sánchez Cotán and El Greco in the same terms.

114 See Jonathan Brown, "El Greco, the Man and the Myths," in *El Greco of Toledo* (Boston: Little, Brown and Company, 1982), pp. 15–33, especially pp. 21–24 for Manuel Cossío's construction of El Greco at the beginning of the twentieth century as the embodiment of the unique national spirit of Spain, and 26–29 for El Greco as a proto-modern artist.

115 Cavestany, *Floreros y bodegones*, pp. 27–28.

116 As noted by Jordan, *Spanish Still Life in the Golden Age*. Orozco Díaz's monograph and catalogue raisonné of Sánchez Cotán was finished by 1964, but published posthumously in 1993. See Javier Portús and Alfonso E. Pérez Sánchez, *Lo fingido verdadero: Bodegones españoles de la colección Naseiro adquiridos para el Prado* (Madrid: Museo Nacional del Prado, 2006), pp. 43–44, on the "essentialist" nationalism of Orozco Díaz and others of his generation. See also Cherry, "El *Bodegón de caza, hortalizas y frutas* de Juan Sánchez Cotán," pp. 199–222.

117 Charles Sterling, *La nature morte de l'antiquité à nos jours* (Paris: Pierre Tisné, 1952), pp. 61–69.

118 Soria, "Sánchez Cotán's *Quince*," p. 226.

119 Soria, "Sánchez Cotán's *Quince*," pp. 226, 227. The perceived "mathematical" order of the picture is echoed by Bergström, *Maestros españoles*, p. 20; Angulo Íñiguez and Pérez Sánchez, *Historia de la pintura española*, p. 61; Pérez Sánchez, *Pintura española de bodegones*, p. 34; Jordan, *Spanish Still Life in the Golden Age*, p. 58.

120 Soria, "Sánchez Cotán's *Quince*," p. 227: "The artist was evidently playing with shapes and volumes, from the pure sphere at the upper left to the one peeling off, as if disintegrating, now cut open and dissected, a slice of it then assuming a different longish shape, finally arriving at a second oblong body, an ellipsoid whole and intact."

121 Mayer, "The Education of the Virgin by Zurbarán," p. 212. Mayer ("A Still-Life by Zurbarán," p. 55) later wrote that the "simplicity" of the composition reminded him of "modern French painting," On Zurbarán's still lifes as proto-modern, see Alessandro Del Puppo, "Qualche caso nella moderna fortuna visiva di Zurbarán," in *Zurbarán (1598–1664)*, ed. Ignacio Cano (Ferrara: Palazzo dei Diamanti, 2013), pp. 98–111, especially 106–10.

122 See, for instance, Émile Bernard and Maurice Denis on Cézanne's "spiritual power" and "mysticism" in Judith Wechsler, *Cézanne in Perspective* (Hoboken, NJ: Prentice-Hall, 1975), pp. 43–44, 52, 53. Sterling, *La nature morte*, p. xxxii, emphasized the "metaphysical" treatment of things (in contrast with the "materiality" of the Flemish school) by Sánchez Cotán and Zurbarán.

123 Mayer, cited in Longhi and Mayer, *Gli antichi pittori spagnoli della collezione Contini-Bonacossi*, p. 40, noted a "primitive" flavor to Zurbarán's works. See also Soria, *The Paintings of Zurbarán*, p. 28. For the "medievalism" of

Sánchez Cotán's figure paintings, see Emilio Orozco Díaz, *Mística, plástica y barroco* (Madrid: Cupsa, 1977), p. 72; and Orozco Díaz, *El pintor Fray Juan Sánchez Cotán*, pp. 143–46.

124 Soria, *The Paintings of Zurbarán*, pp. 10, 11, 12–13. He gives his source for his thinking as Allen Leepa, "Tension and Two-Dimensional Space," chap. 7 in *The Challenge of Modern Art* (New York: Beechhurst Press, 1949), and also quotes Christian Zervos, pp. 28–29. Caturla also thought Zurbarán proto-modernist. See María Luisa Caturla, "New Facts on Zurbarán," *Burlington Magazine* 87, no. 513 (1945): pp. 303–4, which mentions Zurbarán's *Four Vessels*, which entered the Prado in 1940. For her writings on contemporary art, see María Luisa Caturla, *Arte de épocas inciertas*, ed. María Bolaños (Valladolid: Museo Nacional de Escultura, 2021).

125 Del Puppo, "Qualche caso nella moderna fortuna visiva di Zurbarán."

126 Del Puppo, "Qualche caso nella moderna fortuna visiva di Zurbarán," pp. 106–7.

127 Roger Fry, "A Still-Life Painting by Zurbarán," *Burlington Magazine* 62, no. 363 (1933): 253, emphasized its "design ... on the lines of a Primitive painting," its rejection of the principles of impressionism, and its balance of unity and separateness, flatness and modeling. The shapes formed by the emphatic shadow contours in the painting would appear to respond to the black-and-white photograph of the original, first published by Mayer in "A Still-Life by Zurbarán," which emphasizes its plastic values—the volumes and shapes—and consequently its "modernity." Soria considered it a later copy: "Lacking mysticism, it is conceived as a naturalistic still life, not a religious picture"; Soria, *The Paintings of Zurbarán*, 50.

128 Sterling, *La nature morte de l'antiquité a nos jours*, pp. 98–99, cat. no. 73; On p. 65 Sterling emphasizes the naïve elegance of its compositional order, the honesty of its draftsmanship, and its metaphysical dimension. It was sold through Sala Parés in Barcelona in the mid-1940s. See also *Still Life with Basket of Apples and Lemons,* sold at Durán Arte y Subastas, Madrid (October 22, 2015; lot 118, 61 × 71 cm), and catalogued as eighteenth-century or later. This work quotes elements from Zurbarán and Luis Meléndez, painted with a Daliesque meticulousness. For two fake still lifes given to Juan de Zurbarán, see Alfonso Pérez Sánchez and Javier Barón, *Colección Pedro Masaveu: Floreros y bodegones*

(Oviedo: Museo de Bellas Artes de Asturias, 1997), pp. 97–99.

129 See the *Cup of Water and Rose* in the National Gallery, London, sold to Kenneth Clark by Tomás Harris in London in the 1930s, and the *Plate of Quinces* in the MNAC, Barcelona. For the phenomenon of vandalizing pictures for their details, see Ekserdjian, *Still Life before Still Life*, pp. 11–12.

130 As noted by Jordan and Cherry, *Spanish Still Life*, p. 43. The treatment of Sánchez Cotán's still lifes by Bergström, *Maestros españoles*, pp. 17–23, is noteworthy in that he emphasizes their artistic nature—the imitation of nature and their visual pleasures and trompe l'oeil aspect—at the expense of conventional themes of mysticism or religion.

131 Pérez Sánchez, *Pintura española de bodegones*, pp. 27–35. This author was reluctant to relinquish completely the religious readings of Sánchez Cotán's still lifes: see Pérez Sánchez, *Pintura española de bodegones*, p. 28; Pérez Sánchez, *Pintura barroca en España (1600–1750)*, p. 126.

132 Jordan, *Spanish Still Life in the Golden Age*, pp. 43–63; Jordan, *La imitación de la naturaleza*.

133 "First there is the cryptic, celestial selection and arrangement of objects. Learning that hanging fruit from string was standard practice did not undermine the math and magic of Cotán's suspensions for me. Then there is the light, a direct shadow-making light cascades onto each object slightly differently. It wasn't a suspension of time, or a capturing of a moment; the painting was in many different moments and different times. There is the impossible slant of the ledge upon which the sliced melon and cucumber are comfortably resting. And of course there is the limitless depth of the black void behind it all. It wasn't until I met other Cotáns that I realized how crucial the void was in his compositions. The shelf and the wall somehow setting limits on the limitlessness of the darkness just beyond."

Exhibition and Image Credits

EXHIBITION

Curator
Amanda W. Dotseth

Curatorial Assistance
Olivia Turner

Curatorial Consultant
Shannon L. Wearing

Exhibition Development
Bridget LaRocque Marx

Exhibition Management
Loan Registration
Anne Lenhart

Press
Carrie Sanger

Installation
Anne Lenhart
Danielle Naylor
Unified Fine Arts

Graphics
Derrick Saunders
Tom McKerrow

CATALOGUE

Editor
Amanda W. Dotseth

Essay
Peter Cherry

Editorial Management
Anne Keefe and Miranda Saylor

Design
Derrick Saunders

Rights and Reproductions
Danielle Naylor and Faith Wagner

Copyediting and Proofing
Anne Keefe and Shannon L. Wearing

Color Separation, Production, and Printing
Scala

ADDITIONAL CAPTIONS

Pages 3, 5, 9, 30, 63: Juan Sánchez Cotán (Spanish, 1560–1627), *Still Life with Quince, Cabbage, Melon, and Cucumber* (detail), c. 1602. Oil on canvas, 27 $^1/_8$ × 33 $^1/_4$ in. (68.9 × 84.5 cm). San Diego Museum of Art. Gift of Anne R. and Amy Putnam, 1945.43.

Page 39: Juan Sánchez Cotán (Spanish, 1560–1627), *Still Life with Game, Vegetables, and Fruit* (detail), 1602. Oil on canvas, 26 $^3/_4$ × 34 $^3/_4$ in. (68 × 88.2 cm). Museo Nacional del Prado, Madrid, P-7612.

Page 49: Juan Sánchez Cotán (Spanish, 1560–1627); *Still Life with a Basket of Cherries, Roses, Lilies, Asparagus, and Peas* (detail), c. 1600–1603. Oil on canvas, 35 $^3/_8$ × 42 $^7/_8$ in. (89.8 × 109 cm). Private Collection.

Page 61: Juan Sánchez Cotán (Spanish, 1560–1627), *Still Life with Fruits and Vegetables* (detail), c. 1602. Oil on canvas, 26 $^3/_8$ × 38 $^3/_8$ in. (67 × 97.4 cm). Juan Abelló Collection.

Page 68: Installation view of Juan Sánchez Cotán's *Still Life with Quince, Cabbage, Melon, and Cucumber* at the Meadows Museum. Photo by Kevin Todora.

IMAGE CREDITS

Juan Abelló Collection. Image © Joaquín Cortés: fig. 5, fig. 14, p. 61

The Art Institute of Chicago/Art Resource, NY: fig. 3, fig. 9, fig. 19, fig. 23

Digital concept courtesy of Peter Cherry and Jaime García Máiquez: fig. 2

Image courtesy of Galería Caylus: fig. 6, and p. 49

© Madrid, Museo Nacional del Prado: fig. 4, fig. 10, figs. 12–13, fig. 24, p. 39

National Museum in Warsaw. Photo by Krzysztof Wilczyński, fig. 20

© The Norton Simon Foundation: fig. 26

Image courtesy of Patrimonio Nacional: figs. 15–18

San Diego Museum of Art. Photos by Matthew Meier: fig. 1, fig. 8, fig. 25, and pp. 5, 9, 30, and 63.

Museo de Bellas Artes, Granada: fig. 7, fig. 11

David Blázquez: figs. 21–22